Collins

YOU CAN PAINT

Watercolour

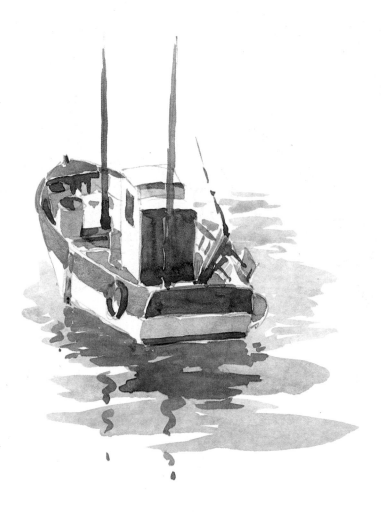

ALWYN CRAWSHAW has been an inspiration to millions of amateur painters and has made seven very popular Channel 4 TV series on painting which have been shown worldwide. He is author of over 20 books on art instruction, all published by Collins, and runs popular painting holidays and courses. He is a regular contributor to *Leisure Painter* magazine, Founder of the Society of Amateur Artists, President of the National Acrylic Painters Association, a member of the Society of Equestrian Artists and the British Watercolour Society and an Honorary Member of the United Society of Artists, as well as a Fellow of the Royal Society of Arts.

YOU CAN PAINT

Watercolour

A step-by-step guide for
ABSOLUTE BEGINNERS

ALWYN CRAWSHAW

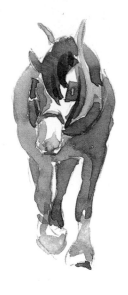

First published in 2000 by
HarperCollins*Publishers*
77-85 Fulham Palace Road
Hammersmith
London W6 8JB

Collins is a registered trademark of
HarperCollins*Publishers* Ltd.

The Collins website address is
www.collins.co.uk

09 08 07 06 05
8 7 6 5 4

**A catalogue record for this book is available from the
British Library**

Editorial Director: Cathy Gosling
Editor: Isobel Smales
Designer: Penny Dawes
Photography: Nigel Cheffers-Heard

ISBN 0 00 413393 5

Colour reproduction by Colourscan, Singapore
Printed and bound by Rotolito Lombarda SpA, Italy

CONTENTS

INTRODUCTION

'I can't paint, I'm not an artist.' People frequently say this to me, and I always reply 'Have you tried?'. Usually the answer is 'No', or 'Yes, I have tried but I'm no good'. I then ask 'But have you been taught how to paint?' and the answer is always 'No'. Well, painting is just like any other art or trade: you have to learn in order to progress. You do not expect to be able to play the piano without having lessons, and so it is with painting. I have been teaching painting for over 35 years, and have drawn on all my experience to write this book, which will introduce you to the wonderful world of watercolour painting.

Watercolour is a very popular medium, which lends itself to painting a wide range of subjects. It also has the great advantage that it requires no complicated equipment, which makes it ideal for a beginner. Even when you are painting outdoors, your basic essentials are a pencil, a box of paints, a brush, paper and water.

The aim of this book is to get you started and then to inspire you to greater heights,

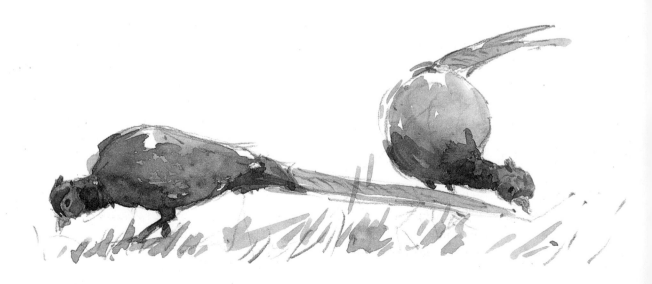

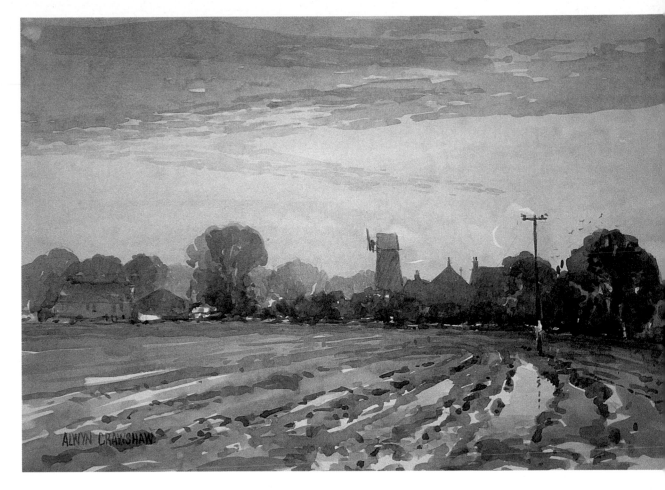

Towards My Studio 28 x 40 cm (11 x 16 in)
Cartridge drawing paper

so I have kept the instructions very simple.
I describe all the materials you will need to make a start, and show you enough basic traditional watercolour techniques to give you a good grounding. It is very important to practise these basic techniques before you try any 'proper' paintings. Try to curb your enthusiasm to rush through the book before you have mastered the basics!

Learning can be challenging and rewarding, and is just as enjoyable as producing a masterpiece. Every time you mix a colour or paint a brush stroke you have learned a little

more and gained experience. The more experience you have the more confident you will be and the more you will want to paint. If you follow the book carefully and practise the exercises with a feeling of excitement and enthusiasm, you will be well on the way to being a watercolour artist. Above all, it is important to enjoy your painting.

HOW TO USE THIS BOOK

This is an instruction book for absolute beginners. It describes the materials you will need, then shows you the basic watercolour techniques and teaches you simple colour mixing. There are exercises and demonstrations for you to copy using the techniques you have learnt. I have kept the instructional text simple and short, and the exercises and demonstrations are broken down into simple stages that are easy to follow.

I recommend that you read the book first without lifting a pencil or a paintbrush. It will

Hickling Church 28 x 40 cm (11 x 16 in)
Cartridge drawing paper

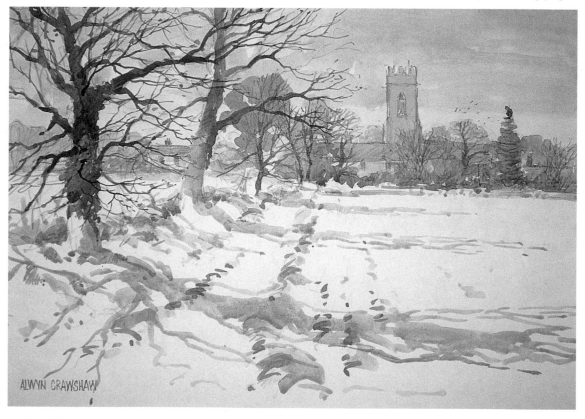

ALWYN CRAWSHAW

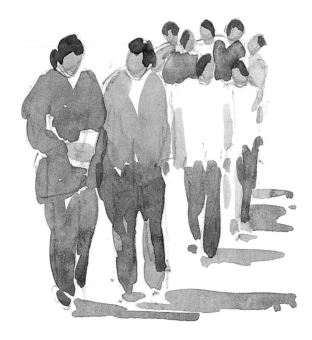

be worth the time you spend! Familiarise yourself with the names of colours, study the techniques to see what each achieves and how it is achieved. Look at the way the paintings progress in the exercises and demonstrations. Once you've read it through, have a go at 'playing' with your materials. Get some inexpensive paper and doodle with your brushes and paints. See what happens when you add water, when you add wet paint onto wet paint, try to paint a thin line, and see how long the paint takes to dry. Make friends with your brushes and the paper before you even try the colour mixing or the different techniques.

When you come to try the demonstrations, you may think that the finished picture is complicated. But remember, it is the end result of a number of more simple stages. If you follow these stages carefully, step by step, you will see how your painting develops. The size I painted the demonstration paintings is shown under each finished stage. Most of the other exercises in the book were painted the same size that they are reproduced.

I am sure that by the time you have reached the end of the book, you will be inspired to have a go at painting some of your own favourite subjects.

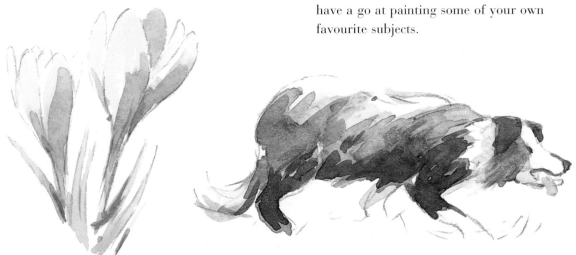

BASIC MATERIALS

As a beginner you do not need to buy a whole range of expensive art materials. The fewer you have, the fewer you have to master. As you gain experience, you will want to change or extend your range of brushes, paper, colours etc. It is good to want to progress and experiment, and watercolour is a wonderful medium for exploring. But at the beginning, let's keep it simple!

Colours I recommend that you use 'pans' rather than tubes of paint. You can control the amount of paint you put on your brush much more easily from a pan. There are two qualities of paint: Students' and Artists'. I use Artists' quality, but Daler-Rowney Students' Georgian are very good and less expensive. I suggest that you have the following colours in your palette: Crimson Alizarin, Yellow Ochre, French Ultramarine, Cadmium Yellow Pale, Cadmium Red, Hooker's Green No. 1, and occasionally Coeruleum blue (see page 18).

Brushes The best watercolour brush you can buy is a sable hair brush. These are also the most expensive as they are made from real sable fur. There are also excellent synthetic brushes on the market (Daler-Rowney's Dalon) that cost much less than sable. I use a No.10 (the number gives the size of the brush hairs), as my big brush, a No.6 (smaller) and a rigger No.2 for thin lines.

Paper There are many different papers on the market. Throughout this book I have used Bockingford watercolour paper and cartridge drawing paper. Both are inexpensive and of excellent quality. They can be bought in different sized pads. Even experienced artists can find it awe-inspiring to sit, brush poised,

Watercolours come in tubes or pans

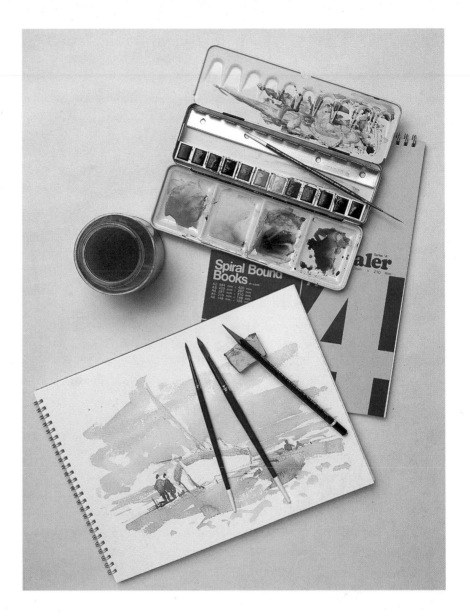

in front of a large, blank piece of paper. It would certainly frighten the hardiest of beginners! The answer is to work small to start with. Don't do any paintings larger than 25 x 38 cm (10 x 15 in), but don't work in 'miniature' either as you won't get the feel for the movement of the paint and the brush on the paper. And a golden rule for watercolour painting is that you must always have your paper at an angle to allow the paint to run slowly down the page.

Other equipment A 2B pencil is a good general drawing pencil, as it is quite soft. I recommend that you use a putty eraser for rubbing out as it can be used gently without causing too much damage to the paper. You will also need a water container, and a jam jar is ideal for this.

Finally, before you venture outside you should get used to working with your materials. This will make painting outdoors much more enjoyable.

TECHNIQUES

There are many ways of applying paint to paper and creating effects. I am sure that you will find some of your own, as you progress. But if you practise the very important basic techniques described on the next few pages, they will show you how your brush, the paper and the paint behave. Most importantly, you will have started on the road to watercolour painting.

Flat wash

The most fundamental technique is the wash. It is the traditional way of applying paint over a large or small area on your paper. The golden rule is to have your paint very watery, so that it runs down and spreads on the paper. The flat wash is the first to practise.

Load your large brush with watery paint. Starting at the top left-hand side of the paper, take the brush along in a definite stroke. At the end, lift the brush off the paper and start another stroke, running it into the bottom of the first wet stroke. Continue in this way, adding more watery paint to your brush as you need it.

Graded wash

This wash is used when you want the colour to get gradually paler. This technique (like all washes) can be worked small.

Work exactly the same way as the flat wash, but gradually add water to the colour mix in your palette to make it paler as you work down the wash.

Graded colour wash

This wash gradually changes colour from top to bottom. I use this technique a great deal for painting skies.

Work the same way as the flat wash but add different colours to the first mixed colour in your palette as you work down. Keep your paint watery.

Wet-on-wet

This is a very exciting watercolour technique. Putting wet colour on to wet colour can give you some of watercolour's 'happy accidents'. These are areas of a painting where you did not control the visual result, but it looks great. Experience will teach you how to create and control some happy accidents.

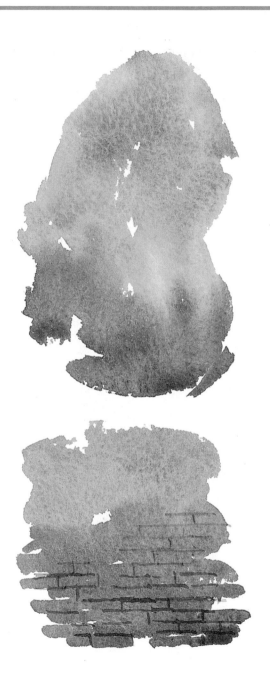

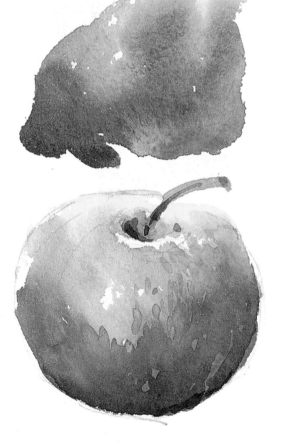

Start with yellow and then add green and finally red. The colours will all blend. When it's dry, add some stronger red to show the markings on the apple.

Let the paint run its own way, changing the colours as you work. When it's dry, suggest bricks with a rigger brush. This technique is ideal for buildings.

Wet-on-dry

This is the way to build up a painting. Remember that if the background paint is wet it merges, but if it is dry you get sharp edges.

Soft edges

There are times when you need to paint a soft edge and not a sharp one. You will find that during a painting you use this technique a lot.

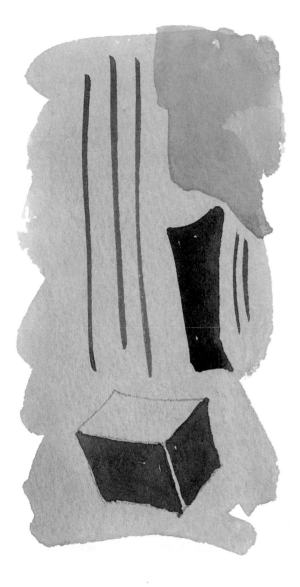

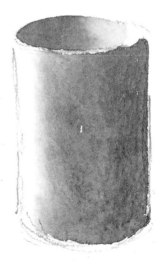

Paint a wash in any colour and let it dry. With different colours paint on top of the dry colour. To paint a thin line use less water on your brush, or it will spread.

Use water for the first stroke, then continue with paint. Also try the reverse; paint a wash and finish with water. This needs plenty of practice.

Dry brush

As the name implies, when you dry brush, the brush has less paint and water and is dragged along hitting and missing the paper and leaving flecks unpainted. It also becomes a natural stroke as you run out of paint on the brush. The rougher the surface of the paper, the more exaggerated the effect will be. When you practise try dabbing the brush on a tissue or blotting paper to remove the excess paint.

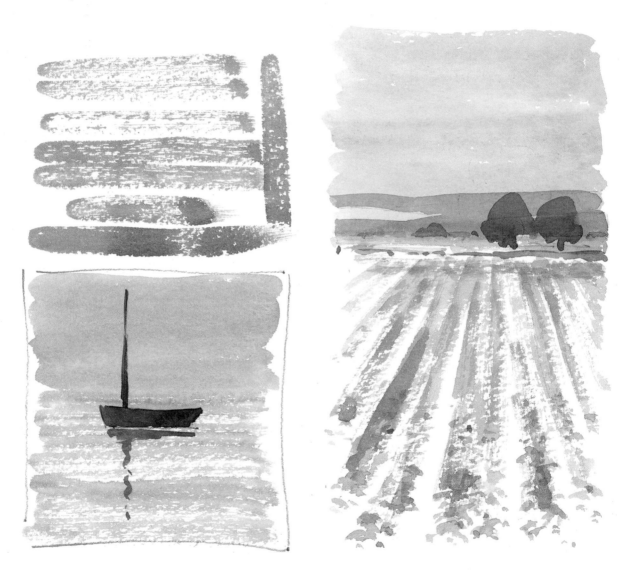

This technique is perfect for sunlit water. Drag the brush in horizontal strokes across the paper. Keep the strokes level, or the water will appear to run downhill!

Drag the brush towards you from the edge of the field. Make the technique more pronounced in the foreground. When dry, add some blobs of darker colour to this area.

Lifting out

Lifting out is when you remove an area of paint. It can be used to take off an excess of colour (either there by accident or design), or as part of the painting's work plan. You will never be able to lift out and leave pure white paper. There will usually be a slight stain, depending on the colour of the paint. Some papers lift out better than others.

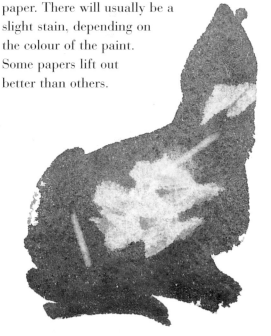

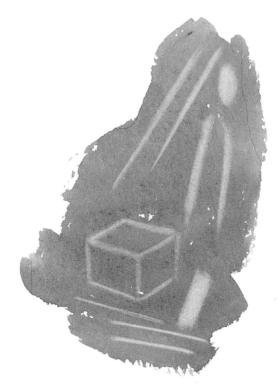

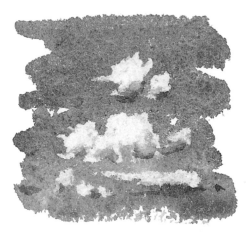

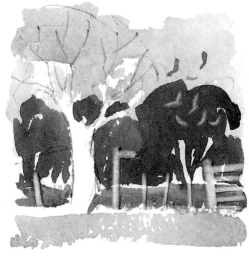

Paint an area of blue and while the paint is wet, sponge out areas with a screwed up soft tissue to represent clouds. This is very simple, but very effective.

With a wet brush, drag the area to be removed over and over again, then blot with tissue. Note that the tree trunk (white paper) is much whiter than the fence and gate I lifted out.

EASY COLOUR MIXING

All the colours that you will need can be mixed using the three primary colours: red, yellow and blue. There are obviously different shades of red, yellow and blue which means that you can mix a wide range of different colours.

Starter palette

When you begin painting in watercolour I recommend that you start with the basic starter palette illustrated below, which will enable you to mix almost any colour you need. These are the colours I use. In fact, for most of my painting I use only Crimson Alizarin, Yellow Ochre and French Ultramarine to mix my colours, but I do use a green when I am painting landscapes. Throughout the book, where I discuss colour mixes, I list the colours in the sequence that you should mix them.

To make colours lighter you need to use more water in your mix (see bottom row below). In order to make the colours darker you add more paint (pigment), or less water.

Basic starter palette

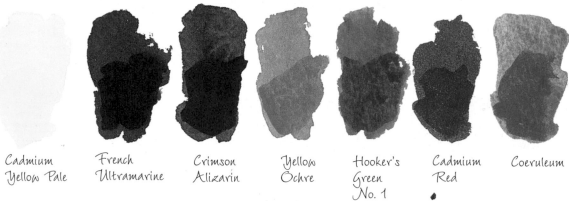

Cadmium Yellow Pale French Ultramarine Crimson Alizarin Yellow Ochre Hooker's Green No. 1 Cadmium Red Coeruleum

Basic colours with added water

The golden rule

The most important rule to remember when mixing a colour is to put the predominant colour of the mix into your palette first (with water) and add smaller amounts of other colours to it. For example, if you wanted to mix a reddy-orange, you would put the predominant colour – red – into your palette and add yellow to it. If you started off with yellow, you would have to mix a lot of red into it to 'overpower' the yellow and make a 'reddy'-orange. You would use a lot more paint, mix more than you need, lose time and get very frustrated. So keep to the golden rule – predominant colour first.

Predominant colour first

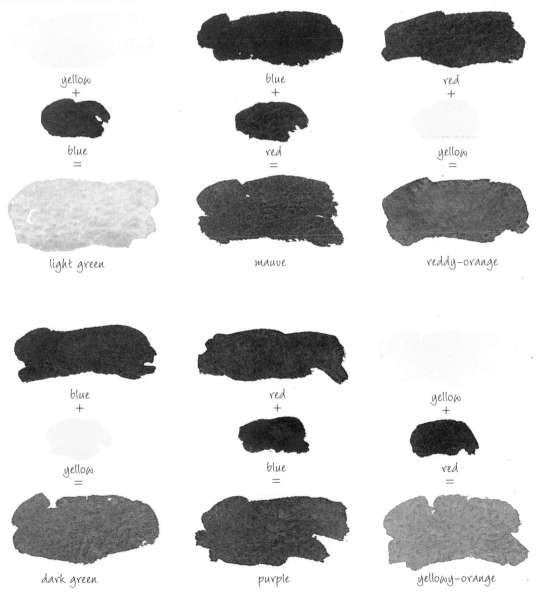

yellow
+
blue
=
light green

blue
+
red
=
mauve

red
+
yellow
=
reddy-orange

blue
+
yellow
=
dark green

red
+
blue
=
purple

yellow
+
red
=
yellowy-orange

Mixing only three colours

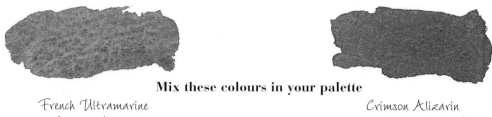

Mix these colours in your palette

French Ultramarine
+ Crimson Alizarin
+ Yellow Ochre

Crimson Alizarin
+ Yellow Ochre
+ French Ultramarine

Then add the other colours below to the above colour mix in the palette, and test the colour.

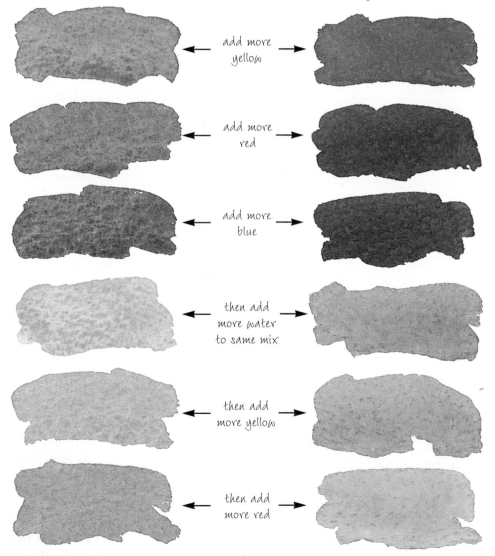

← add more yellow →

← add more red →

← add more blue →

← then add more water to same mix →

← then add more yellow →

← then add more red →

More colour mixing

Hooker's Green No. 1
+ Crimson Alizarin

Now try adding the colours below to the above mix

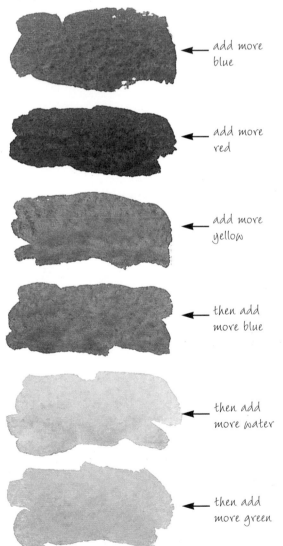

← add more blue

← add more red

← add more yellow

← then add more blue

← then add more water

← then add more green

Remember that adding water is like adding white – it makes the colours paler

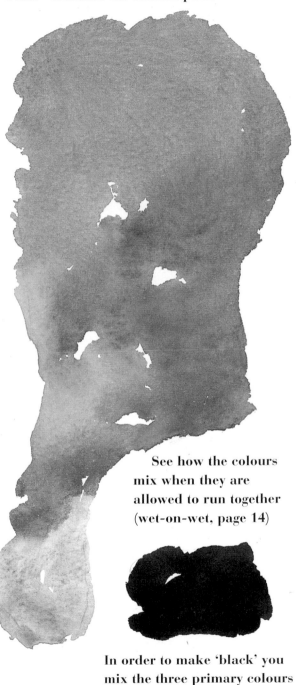

See how the colours mix when they are allowed to run together (wet-on-wet, page 14)

In order to make 'black' you mix the three primary colours with a small amount of water

MAKING OBJECTS LOOK 3D

This is perhaps the most important lesson to master. If you don't have contrast, your picture will be flat, with no recognisable shape or form. Look at the paintings below. The objects only become real when you add shadows. Remember that light against dark will always show shape and form and make an object look three dimensional.

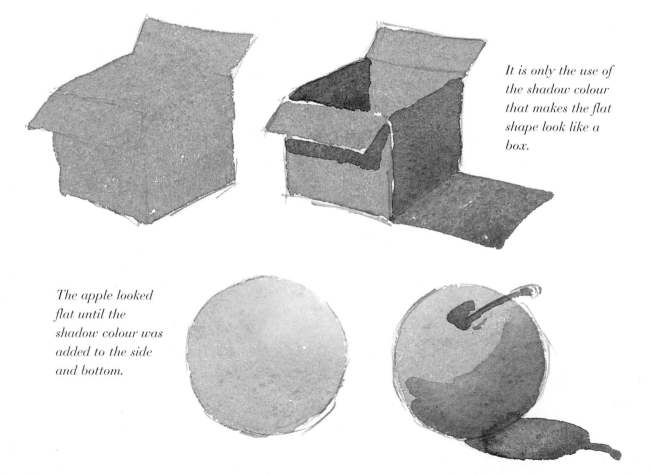

A mix of French Ultramarine, Crimson Alizarin and a touch of Yellow Ochre will give you a good general shadow colour.

It is only the use of the shadow colour that makes the flat shape look like a box.

The apple looked flat until the shadow colour was added to the side and bottom.

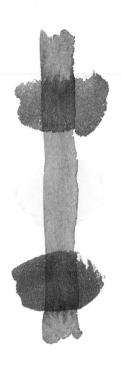

Because watercolour is transparent, the shadow colour (the vertical line) allows the underneath colour to show through – but darker.

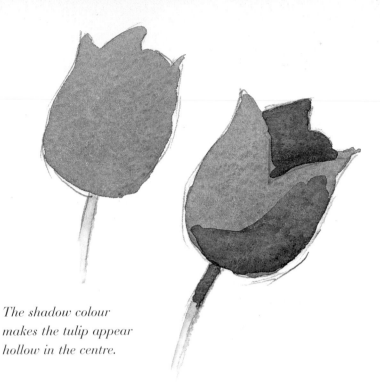

The shadow colour makes the tulip appear hollow in the centre.

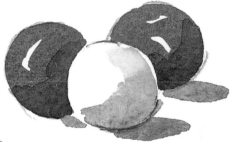

Notice how the white ball doesn't exist without the shadow. Also, the little highlight of white paper left on each ball makes them look shiny and spherical.

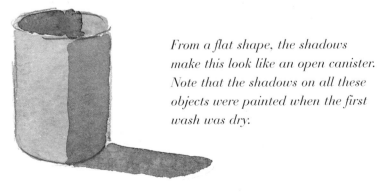

From a flat shape, the shadows make this look like an open canister. Note that the shadows on all these objects were painted when the first wash was dry.

FRUIT

The great thing about painting fruit is that you usually have some in the house!
You can make a picture out of just one apple or a whole basket of fruit. In fact,
fruit is an ideal subject on which to practise techniques and colour mixing.

Peach

Like most fruit, a peach can have many colours. These range from bright yellow to deep reddy-
purple. They are warm colours and are very powerful and exciting. When you are starting out,
don't try to capture the velvet texture of the skin. Concentrate on the shape and form.

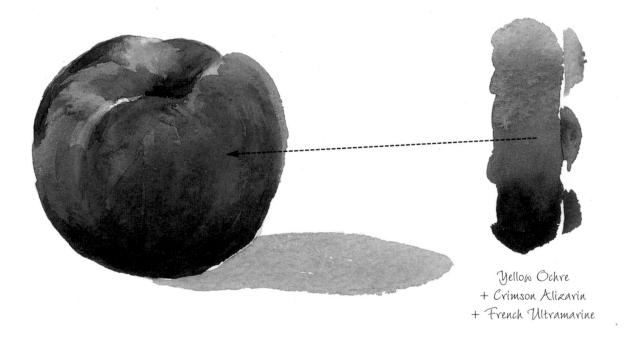

Yellow Ochre
+ Crimson Alizarin
+ French Ultramarine

*When I painted this peach I wanted to show
how to make it sit on the ground. This was
done in two ways. The first was by painting a
very dark area at the bottom of the peach.*

*This made it appear to be a round object,
but it still looked as if it was 'floating' on the
page. Adding the shadow made it sit on the
ground.*

Colourful cherries

Like peaches, cherries also have vibrant colours. They are very simple to draw and there are not large areas to cover with paint. This is a good example of how small you can paint a wash. Although the wash used on the cherry is very small in comparison to, say, a wash on a sky, the technique is the same.

Cadmium Yellow Pale

1 *Draw the cherries using your 2B pencil. Paint in the lighter yellow colour at the top and gradually add red (wet-on-wet, page 14). Leave a highlight of white paper on each cherry.*

Crimson Alizarin

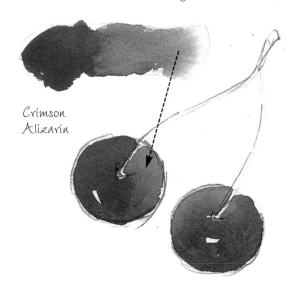

2 *Now paint in the stalks using your rigger brush. Try to paint each stalk with one brush stroke.*

Cadmium Yellow Pale

French Ultramarine

Crimson Alizarin

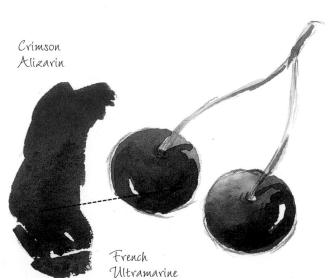

French Ultramarine

3 *Make sure the cherries are dry then paint in the darker shadow colour around the bottom and right hand side of the cherries.*

Banana

This is another fruit that is not complicated to draw. When you have had a go at copying mine, try painting one from life. You might find the drawing more difficult, but copying this one will have given you more confidence.

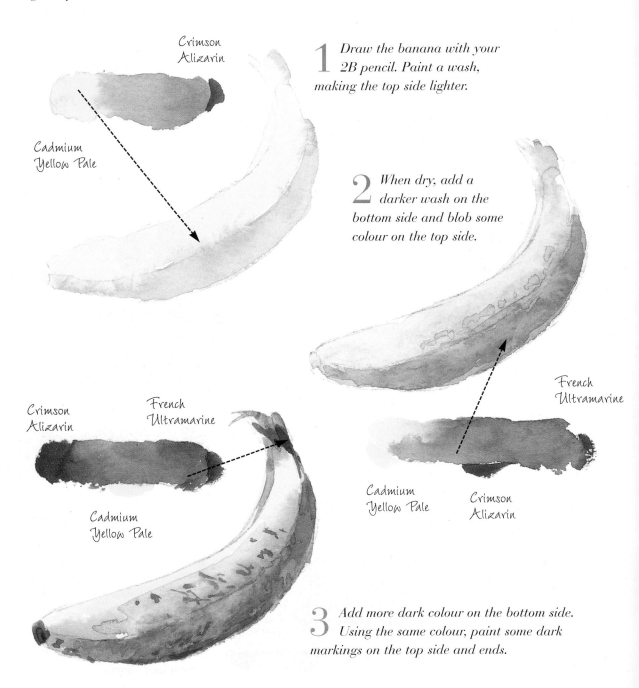

Crimson Alizarin

Cadmium Yellow Pale

1 Draw the banana with your 2B pencil. Paint a wash, making the top side lighter.

2 When dry, add a darker wash on the bottom side and blob some colour on the top side.

French Ultramarine

Cadmium Yellow Pale

Crimson Alizarin

Crimson Alizarin

French Ultramarine

Cadmium Yellow Pale

3 Add more dark colour on the bottom side. Using the same colour, paint some dark markings on the top side and ends.

Juicy grapes

These appear to be the most difficult of the fruit to paint, but if you look carefully, it's only like painting a lot of cherries, although different shapes and colours. Study them carefully before you start. Notice how in the finished stage light against dark and dark against light play an important part in making the grapes look 3D (page 22).

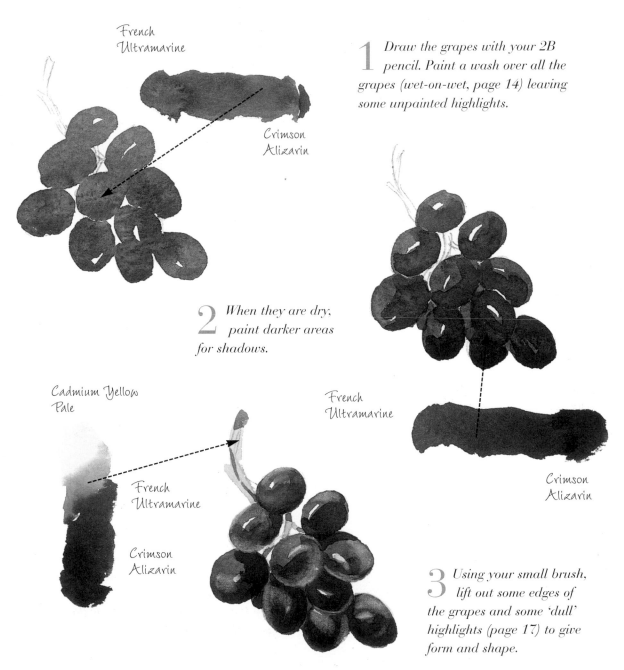

French
Ultramarine

Crimson
Alizarin

1 *Draw the grapes with your 2B pencil. Paint a wash over all the grapes (wet-on-wet, page 14) leaving some unpainted highlights.*

2 *When they are dry, paint darker areas for shadows.*

Cadmium Yellow
Pale

French
Ultramarine

French
Ultramarine

Crimson
Alizarin

Crimson
Alizarin

3 *Using your small brush, lift out some edges of the grapes and some 'dull' highlights (page 17) to give form and shape.*

DEMONSTRATION FRUIT

 AT A GLANCE...

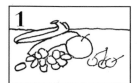 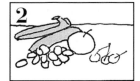 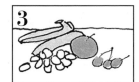 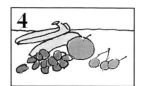

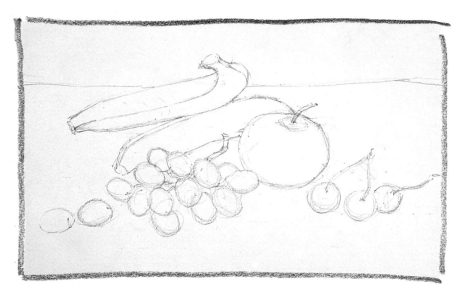

1 Draw the fruit with your 2B pencil. Be positive with the pencil. It doesn't matter if the pencil lines still show through when the painting is finished. Start by drawing the first banana and work down to the grapes and cherries.

2 Using your small brush, paint the first wash on the bananas. Make the top side of the first banana lighter and the bottom side darker. This gives it form and dimension. Keep the painting simple at this stage.

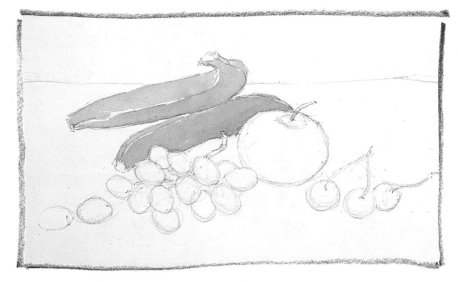

The palette

French Ultramarine

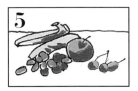
5
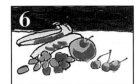
6

Crimson Alizarin

Cadmium Yellow Pale

3 With the same brush, paint in the apple. Work your wash wet-on-wet (page 14), changing the colours as you work down the apple. Leave some unpainted highlights. Now paint the cherries in the same way, also leaving some highlights.

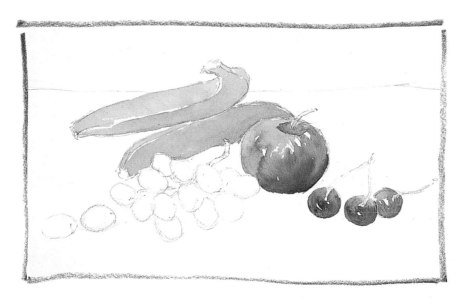

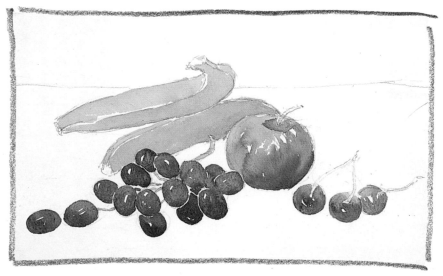

4 Continue with the first wash on the grapes. Don't worry at this stage if the fruit is not looking 'strong' enough. This is only the first wash and it is the next stage that will give strength and character to the fruit.

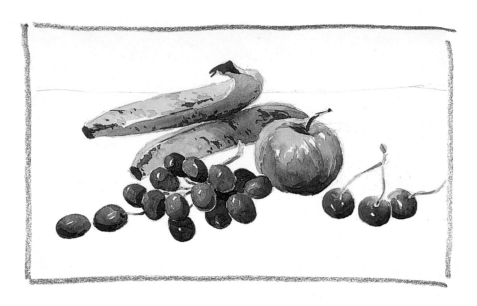

5 *Paint in darker shadow areas on all the fruit and make sure they are dark enough to make the fruit appear 'round'. Remember to follow the shape of the fruit with your brush strokes. Next paint the dark markings on the bananas and the stalks on the other fruit.*

Detail: The dark markings on the bananas are simple brush strokes, but they follow the contour of the banana. The top of the apple comes away from the banana because the apple is light against the dark shadow of the banana.

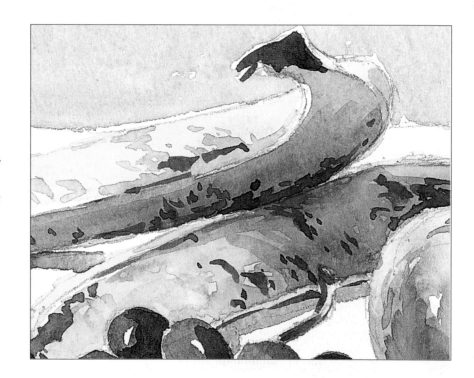

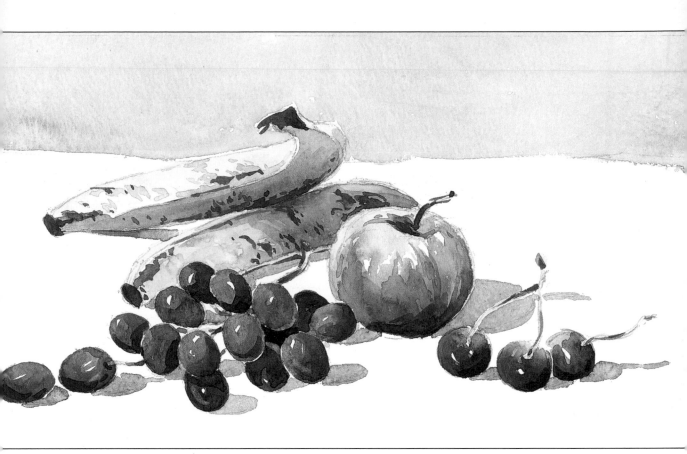

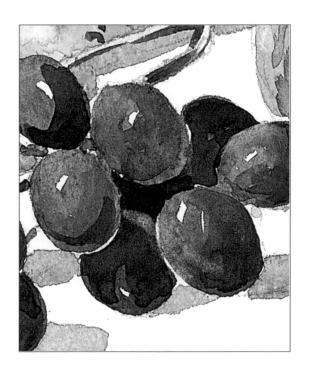

6 *Finished picture:* Bockingford watercolour paper, 19 x 30 cm (7½ x 12 in). Using your big brush, paint in the background colour. Now mix a shadow colour with your small brush and paint in the shadows cast on the table. This makes the fruit 'sit' and not 'float' on the paper. Finally add any darks (accents) you feel will help your painting.

Detail: Two grapes have their shape defined by lifting out their edges with a brush.

VEGETABLES

Like fruit, this is a subject that you can practise painting indoors to learn the techniques and the magic of watercolour under controlled conditions. This is important at the beginning, when you want as little interruption to your concentration as possible. There's enough to think about with the painting!

Green pepper

A pepper can look like a ceramic ornament, because of its smooth, shiny, bulbous shape and its very bright colouring. A pepper is a challenge to paint, so try painting the other simpler vegetables on the next pages first, then have a go at copying mine.

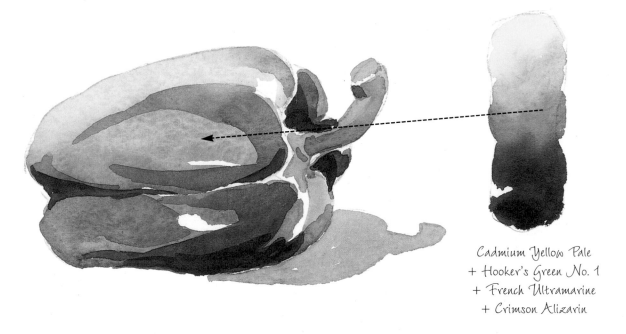

Cadmium Yellow Pale
+ Hooker's Green No. 1
+ French Ultramarine
+ Crimson Alizarin

The most important part of this painting was to capture the reflected shapes and shadows. I looked at the pepper very carefully to see 'shapes' of colour and tone (light against dark).

I began by using a wet-on-wet technique (page 14). When the wash was dry I painted darker shapes on top. Note the white paper I left for highlights.

Carrot

A carrot is easy to draw and not complicated to paint. Its main colour is orange, but you still use the three primary colours to mix from. To paint the carrot use a graded colour wash technique (page 13).

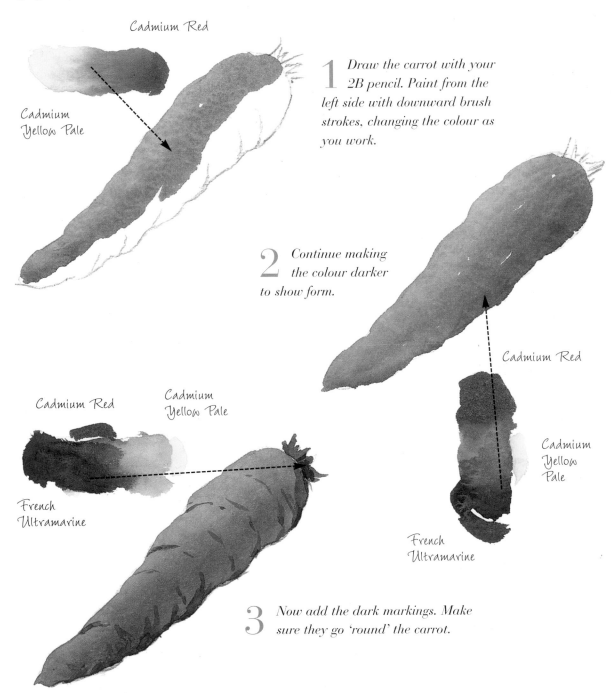

Cadmium Red

Cadmium Yellow Pale

1 *Draw the carrot with your 2B pencil. Paint from the left side with downward brush strokes, changing the colour as you work.*

2 *Continue making the colour darker to show form.*

Cadmium Red

Cadmium Yellow Pale

Cadmium Red

Cadmium Yellow Pale

French Ultramarine

French Ultramarine

3 *Now add the dark markings. Make sure they go 'round' the carrot.*

Radishes

Radishes are very much like cherries and grapes to paint except they have extra drawing on the top and bottom. If you look at vegetables and fruit with an artistic eye, many of them are very similar in shape and are relatively easy to draw.

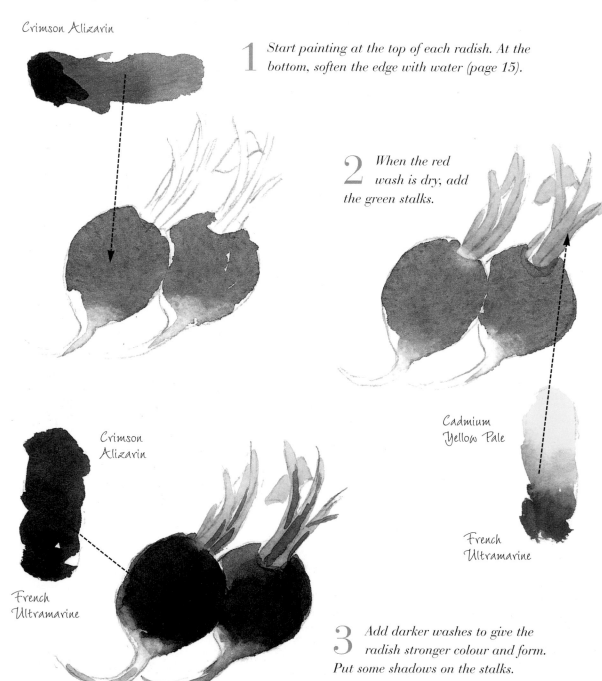

Crimson Alizarin

1 *Start painting at the top of each radish. At the bottom, soften the edge with water (page 15).*

2 *When the red wash is dry, add the green stalks.*

Cadmium Yellow Pale

French Ultramarine

Crimson Alizarin

French Ultramarine

3 *Add darker washes to give the radish stronger colour and form. Put some shadows on the stalks.*

Onion

By now if you have been practising you will be very familiar with making objects look round in shape. The onion is another round vegetable. It lends itself very well to watercolour, because the skin is suggested with thin transparent washes.

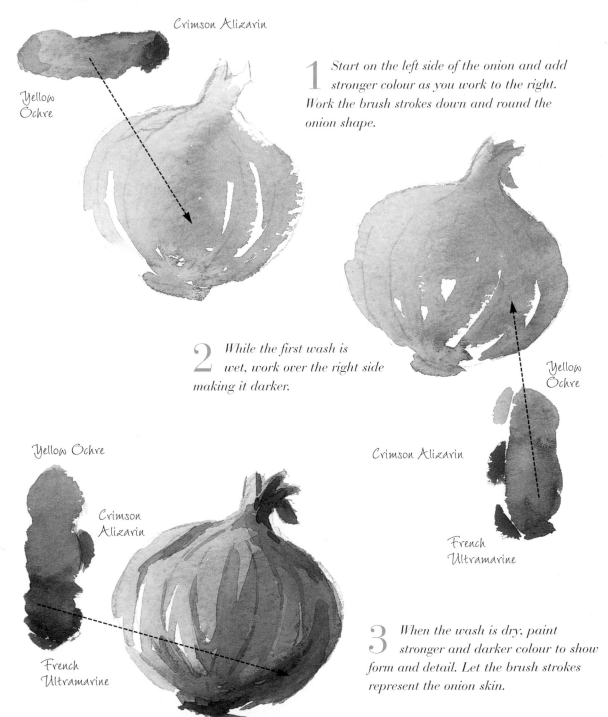

Crimson Alizarin

Yellow Ochre

1 *Start on the left side of the onion and add stronger colour as you work to the right. Work the brush strokes down and round the onion shape.*

2 *While the first wash is wet, work over the right side making it darker.*

Yellow Ochre

Crimson Alizarin

French Ultramarine

Yellow Ochre

Crimson Alizarin

French Ultramarine

3 *When the wash is dry, paint stronger and darker colour to show form and detail. Let the brush strokes represent the onion skin.*

DEMONSTRATION VEGETABLES

 AT A GLANCE...

 1
 2
 3
 4

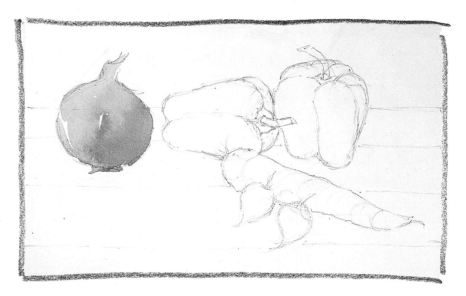

1 Draw in the vegetables with your 2B pencil. Use your big brush and mix a wash of Yellow Ochre and Crimson Alizarin. Paint the first wash on the onion. Work the brush strokes down and round the shape of the onion.

2 Use Crimson Alizarin and Cadmium Red for the red pepper, Cadmium Yellow Pale and Yellow Ochre for the yellow pepper (leave highlights), Cadmium Yellow Pale and Cadmium Red for the carrot and Crimson Alizarin and French Ultramarine for the radishes.

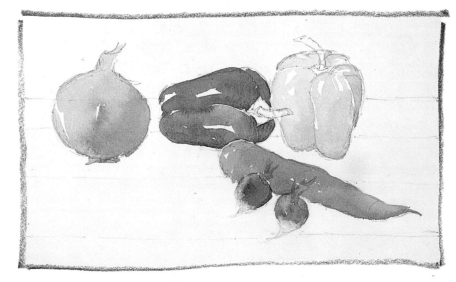

The palette

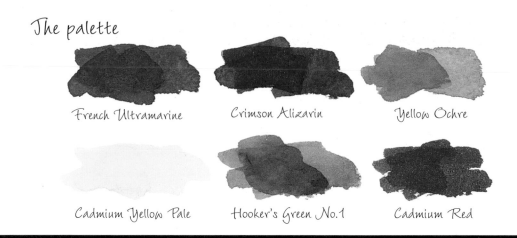

French Ultramarine Crimson Alizarin Yellow Ochre

Cadmium Yellow Pale Hooker's Green No.1 Cadmium Red

3 *Now paint in the shadow (dark) areas on the vegetables, and add some modelling (darker areas to show form). When the vegetables are dry, paint in the stalks. Use your small brush for small or detailed work. Now paint in the table top with your big brush.*

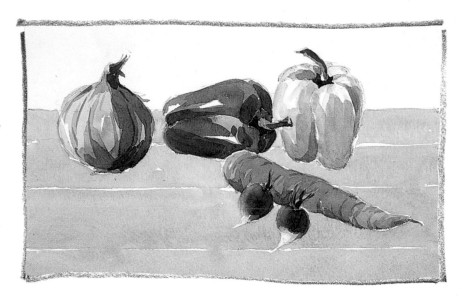

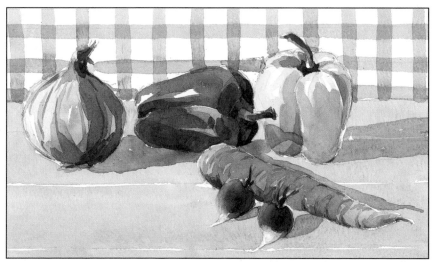

4 **Finished picture:** *Bockingford watercolour paper, 19 x 30cm (7½ x 12 in). Using single strokes of your big brush, paint in the checked background Mix a shadow colour and paint the shadows on the table. Notice how the red from the pepper ran into the shadow – a happy accident!*

FLOWERS

This is another subject that can be painted indoors. After copying these you could try painting one in your garden. In general the shapes are a little more complicated than the fruit and vegetables, but if you have been practising you shouldn't have any problems.

Daisy

I think that the daisy is one of the most positive flower shapes to paint. The petals can vary in size and position, and it is relatively simple to draw. Because the petals are white, in watercolour they can be left as unpainted paper with simple shadows painted on them.

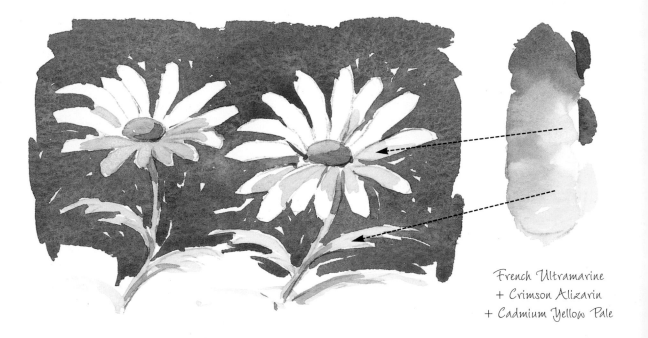

French Ultramarine
+ Crimson Alizarin
+ Cadmium Yellow Pale

The most important part of this painting was the blue sky background. This was done as a flat wash, but with the brush going in all directions to paint up to the petals. Remember, the secret of a good wash is to make sure your paint is very watery.

Crocus

There are some wonderful crocus colours to paint. Crocuses are only small flowers, but when they come up in early spring they really make you feel as if winter has gone. Because of their colour, the yellow ones remind me most of spring.

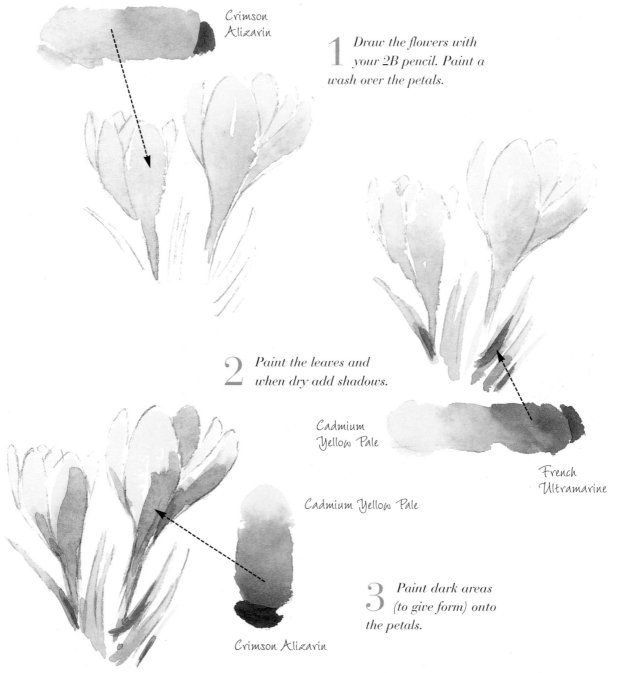

Cadmium Yellow Pale

Crimson Alizarin

1 Draw the flowers with your 2B pencil. Paint a wash over the petals.

2 Paint the leaves and when dry add shadows.

Cadmium Yellow Pale

French Ultramarine

Cadmium Yellow Pale

Cadmium Yellow Pale

Crimson Alizarin

3 Paint dark areas (to give form) onto the petals.

Fuchsia

If you like strong colour, then the fuchsia couldn't be a better flower to paint. With its vibrant red and mauve, it is not a watercolour subject for the faint-hearted! Have a go with strong colour and enjoy it.

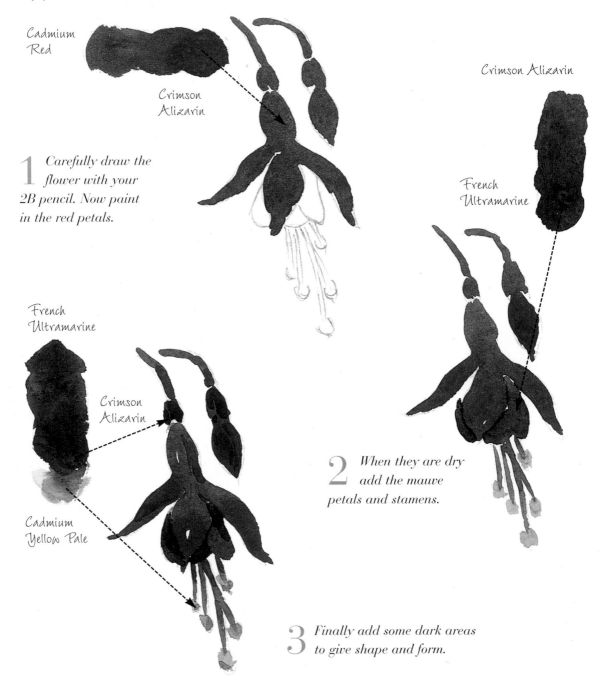

Cadmium Red

Crimson Alizarin

1 Carefully draw the flower with your 2B pencil. Now paint in the red petals.

Crimson Alizarin

French Ultramarine

French Ultramarine

Crimson Alizarin

Cadmium Yellow Pale

2 When they are dry add the mauve petals and stamens.

3 Finally add some dark areas to give shape and form.

Snowdrop

Painting a snowdrop is like painting a crocus upside down. Because it is white like the daisy it needs a dark background to help show its shape. With the daisy I painted the background first, but I have painted it last with the snowdrop.

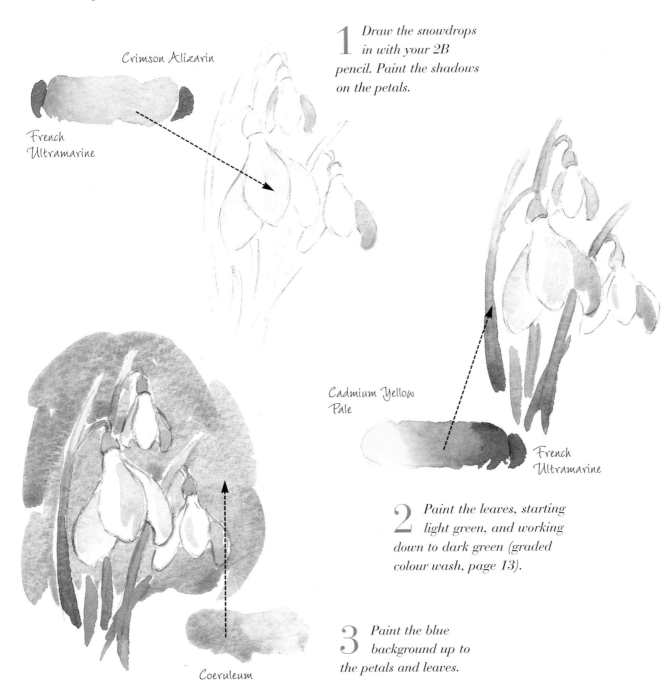

Crimson Alizarin

French Ultramarine

1 *Draw the snowdrops in with your 2B pencil. Paint the shadows on the petals.*

Cadmium Yellow Pale

French Ultramarine

2 *Paint the leaves, starting light green, and working down to dark green (graded colour wash, page 13).*

Coeruleum

3 *Paint the blue background up to the petals and leaves.*

DEMONSTRATION FLOWERS

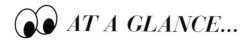

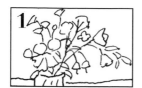 *AT A GLANCE...*

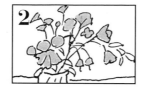

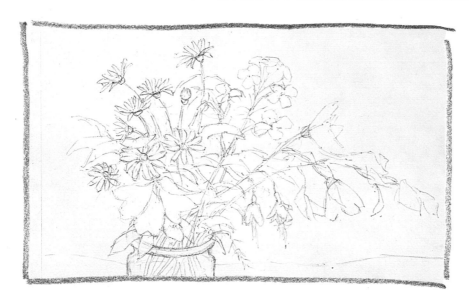

1 When the drawing looks complicated, it is important to study it first. Draw in the flowers and vase with your 2B pencil. Draw the flowers carefully; they are more important to the overall picture than the leaves.

2 Paint in the first wash on the flowers. Leave the daisies white except for the petals in shadow, and then paint in the yellow centres. For the pink flowers add just a little Cadmium Yellow Pale to Crimson Alizarin.

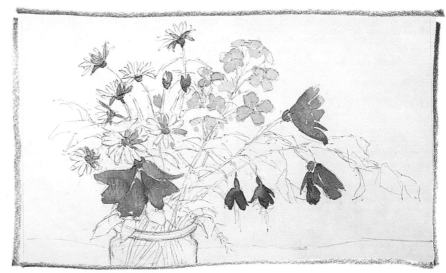

42 You can paint

French Ultramarine Cadmium Yellow Pale Crimson Alizarin

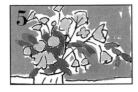
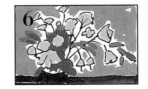

Yellow Ochre Hooker's Green No.1

3 *Using a mix of French Ultramarine, Crimson Alizarin and Yellow Ochre, paint the background with your big brush. Start at the top left and work down. Change colours as you work wet-on-wet (page 14). Use your small brush to work round the complicated areas.*

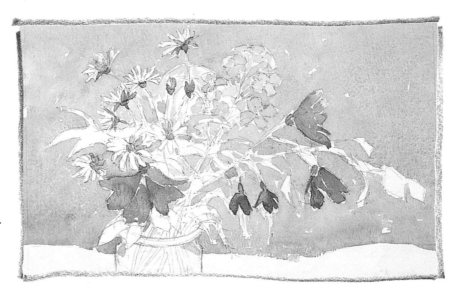

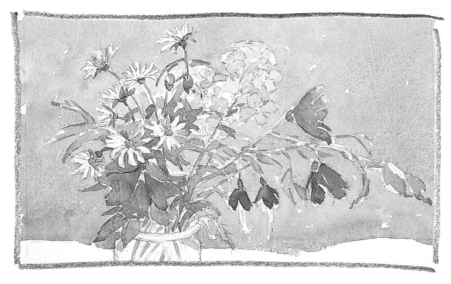

4 *When the wash is dry, paint in the leaves and stalks with a varying mix of Cadmium Yellow Pale, Hooker's Green No.1 and French Ultramarine. Work carefully round the flowers, especially the white daisies.*

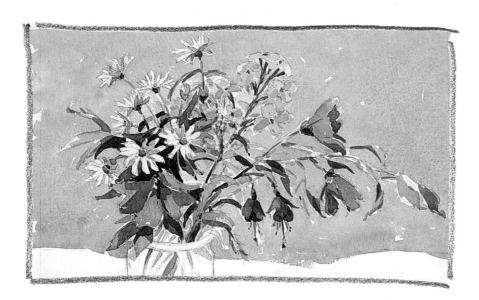

5 Using a darker green mix, paint the dark shadows and shapes of the leaves and stalks. Again be careful working round the flowers. Notice how the daisies now stand out and appear whiter. Paint a second wash on the other flowers to give them form.

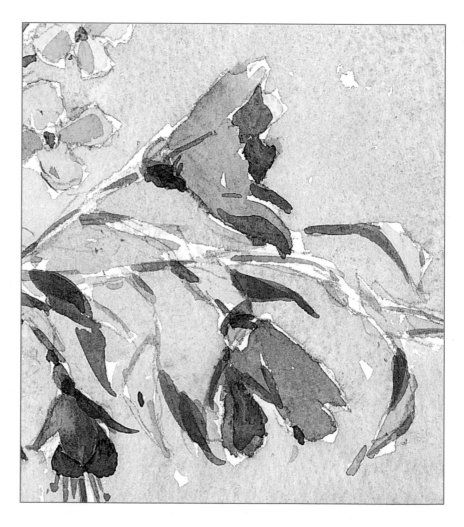

Detail: The mauve flower has been painted with only two washes. Look how the second wash – the darker wash – has made the flower look 3D from a 'flat' shape (see stage 2).

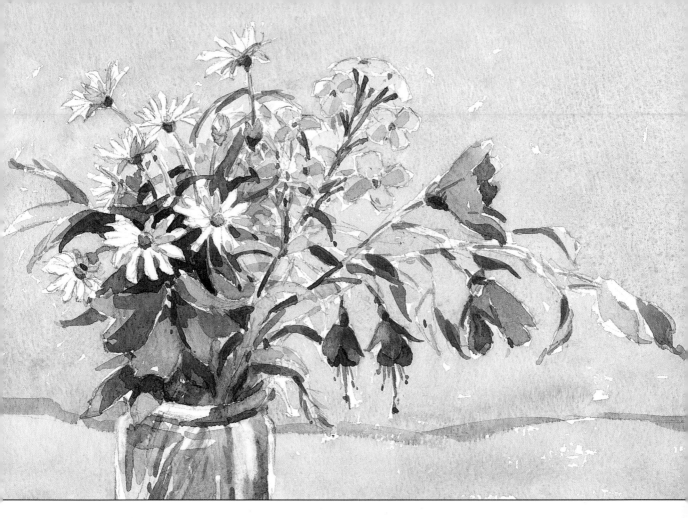

6 *Finished picture: Bockingford watercolour paper, 19 x 30 cm (7½ x 12 in). Paint the foreground orange strip with your big brush. Paint over the edges of the background and into the glass vase in places. Paint some flower stems in the vase. Finally, using the background colour with a little more blue added, paint a wash on the vase, leaving highlights.*

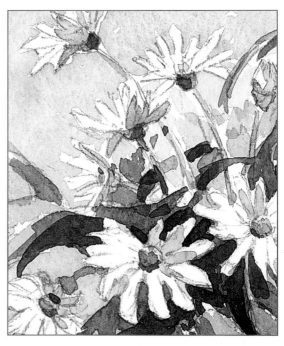

Detail: It is important to leave white paper for the daisy petals when you paint the background. It is this that gives them their shape.

SKIES

Skies are very inspirational. They set the mood for a landscape painting. You can look at them almost any time, from outside or through a window, so they are a subject that you are very familiar with. But to paint them, you need to observe them more closely.

Heavy clouds

When you practise skies, always suggest the land as I have done in the painting below. This gives scale to your sky. Notice how the clouds, painted very simply, get smaller and narrower to the horizon, and the darker clouds are nearer to you. This gives the impression of distance.

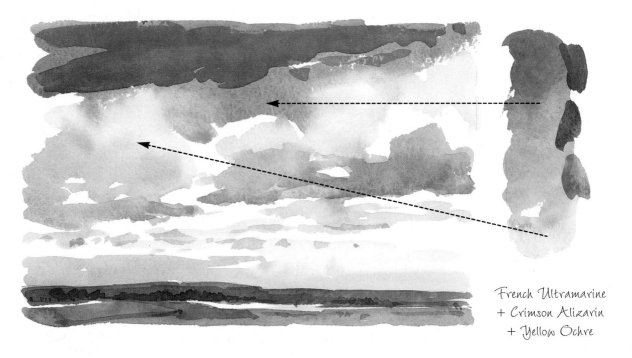

French Ultramarine + Crimson Alizarin + Yellow Ochre

I painted the blue sky first and while it was wet, painted the clouds (wet-on-wet, page 14). I allowed some clouds to run and merge with the sky. When the paint was dry, I painted darker shadows on the clouds, and the very heavy dark cloud at the top over the original blue sky.

Sunset

A sunset in any landscape painting runs the risk of looking a little 'over the top'. This is simply because a real sunset is often very vivid with its vibrant colours and strong shapes. The answer, until you get more experience, is to tone down the colours.

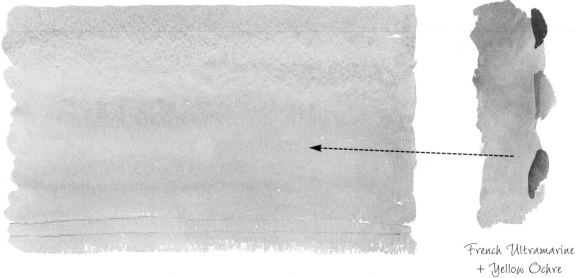

French Ultramarine
+ Yellow Ochre
+ Crimson Alizarin

1 *Paint a graded colour wash (page 13) for the underpainting, to give an all-over background colour.*

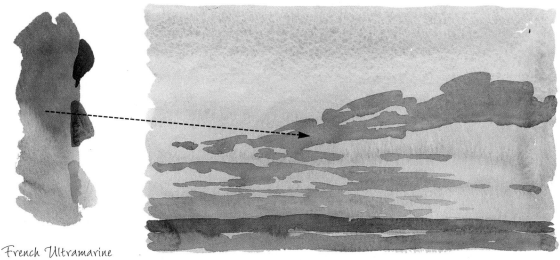

French Ultramarine
+ Crimson Alizarin
+ Yellow Ochre

2 *When the first wash is dry, paint in the clouds using positive and confident brush strokes, making them narrower nearer to the horizon (wet-on-dry; page 15).*

Soft clouds

The heavy cloudy sky (page 46) was painted with a lot of crisp edges. This sky is painted with soft edges (page 15). The clouds are further away and not overhead. There isn't a lot of definition in the clouds, which helps to make them look as if they are a long way off.

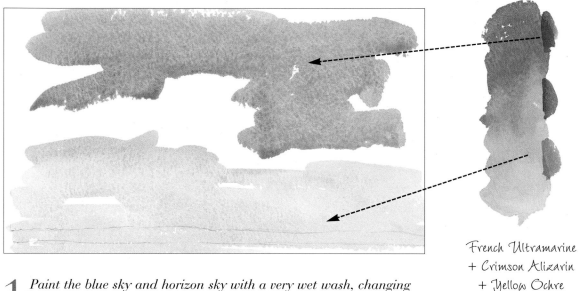

French Ultramarine
+ Crimson Alizarin
+ Yellow Ochre

1 *Paint the blue sky and horizon sky with a very wet wash, changing the colour as you paint (wet-on-wet, page 14).*

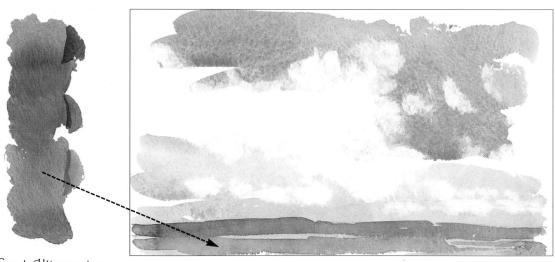

French Ultramarine
+ Crimson Alizarin
+ Yellow Ochre

2 *While the paint is still very wet, lift out the cloud shapes from the wet background sky with a screwed up soft tissue (lifting out, page 17). When dry, suggest the land.*

Rainy sky

This type of sky always looks dramatic in a painting. As you are painting wet-on-wet, there will be happy accidents, but you can also get unhappy ones. So if it doesn't work it's not your fault! Try experimenting with other colours for the sky – for example, sunset colours.

Yellow Ochre

1 Paint a wash from the left, with diagonal downward brush strokes working to the right. Leave a white (paper) area to represent sunlight.

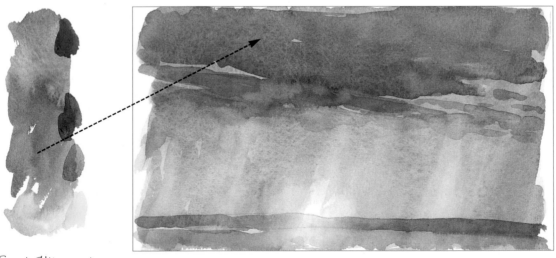

French Ultramarine
+ Crimson Alizarin
+ Yellow Ochre
+ Cadmium Yellow Pale

2 Now paint the land. When this is dry, paint a wash over the whole sky and land. When dry, paint the dark clouds at the top and blend in to the 'rain' effect. Lift out sunlit areas with a brush (page 17).

EXERCISE Paint a sky

When you paint this exercise, the first three stages are done while the paint is wet. So you can't be interrupted while you are painting these stages. Have your coffee when you finish! Use this picture as a guide – it's impossible to copy mine exactly.

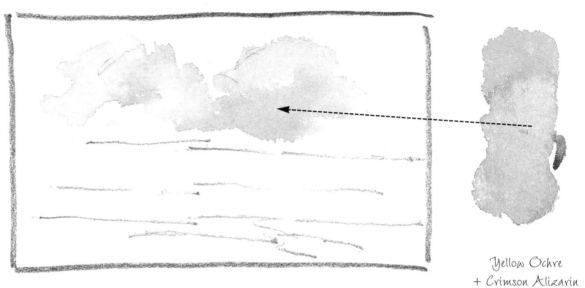

Yellow Ochre + Crimson Alizarin

1 *Draw the main features with your 2B pencil. Then paint the main cloud formation (wet-on-wet, page 14).*

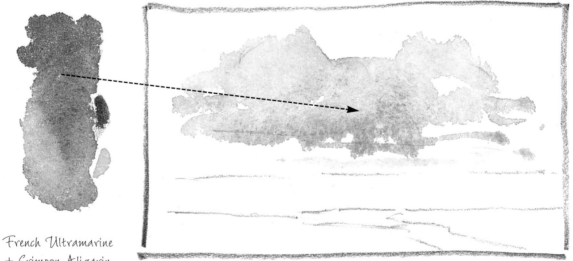

French Ultramarine + Crimson Alizarin + Yellow Ochre

2 *Add shadow colour to the clouds (page 22). Put your brush into the yellow and paint down.*

The palette

French Ultramarine

Crimson Alizarin

Yellow Ochre

Hooker's Green No. 1

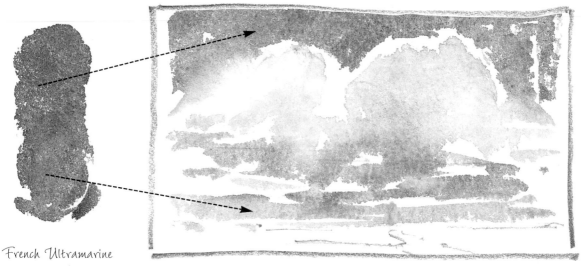

French Ultramarine
+ Crimson Alizarin

3 *Paint in the blue sky above and below the main clouds. Leave white paper edges and in some places let the blue merge into the clouds.*

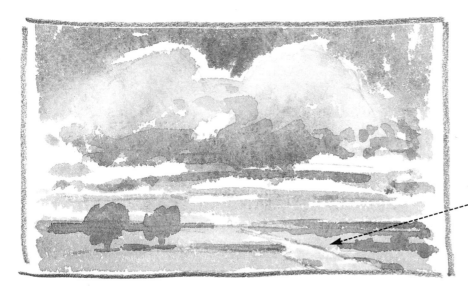

Hooker's Green No. 1
+ Yellow Ochre
+ Crimson Alizarin
+ French Ultramarine

4 *When the sky is dry, paint a stronger shadow colour under the main clouds. Then paint the land.*

TREES

Trees are one of my favourite subjects. There are plenty of different shapes and sizes to work from, and of course they change their look and colouring during the four seasons. When you paint trees, keep them simple, and remember that like a vivid sunset, a full autumn colouring can look over the top, so tone the colours down!

Winter willow

Willows have a very distinctive shape and can't be mistaken for any other tree. They grow in wet areas by or near rivers and lakes. If you're working from your imagination don't paint willows on hills, they would look wrong!

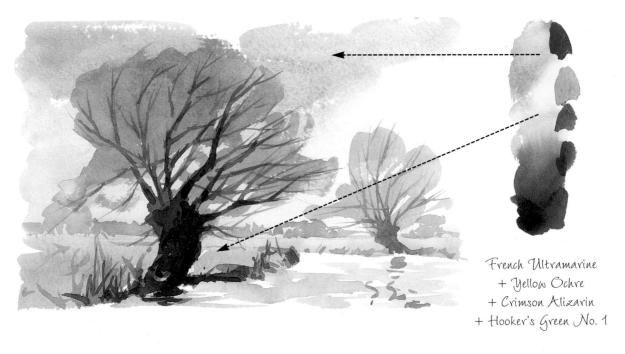

French Ultramarine
+ Yellow Ochre
+ Crimson Alizarin
+ Hooker's Green No. 1

I painted the trees on the background once it was dry. The further tree is painted in just two washes; the trunk and branches first, then a wash for the overall shape. The foreground tree was done the same way but with more work on the trunk. Note how I have put them near water.

Winter tree

It is a good idea to start by drawing winter trees. You then see all the branches, and the way the tree forms its shape.

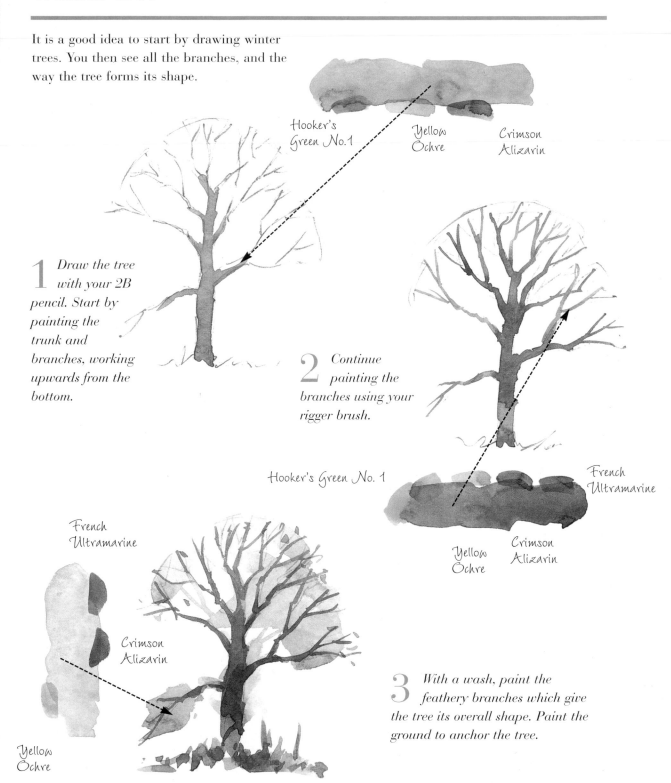

Hooker's Green No.1

Yellow Ochre

Crimson Alizarin

1 *Draw the tree with your 2B pencil. Start by painting the trunk and branches, working upwards from the bottom.*

2 *Continue painting the branches using your rigger brush.*

Hooker's Green No. 1

French Ultramarine

Yellow Ochre

Crimson Alizarin

French Ultramarine

Crimson Alizarin

Yellow Ochre

3 *With a wash, paint the feathery branches which give the tree its overall shape. Paint the ground to anchor the tree.*

Sketching trees

When you are outdoors with your pencil and sketchbook, make sketches of trees or any parts of trees that interest you. Make notes at the side or on the back of the paper. If you have your paints, then add colour. These pages give you an idea of what to look for.

Trunk – make it grow
Paint plenty of growth around the base of the trunk.

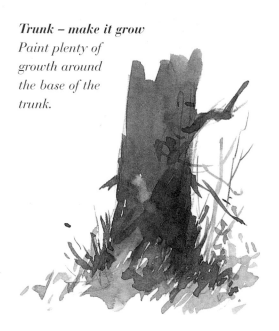

Leaves
Remember to use dark against light; paint light coloured leaves then add dark ones.

Thin branches
Use your rigger brush with plenty of water. The thinner the branch the less water is needed.

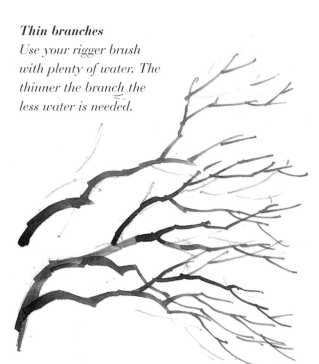

Log
Painting simple lines down the log helps to give it form and suggests bark.

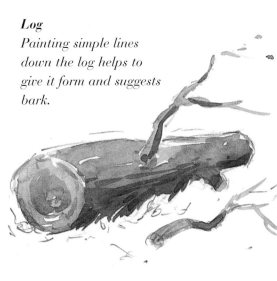

Fir tree silhouette
This can be very effective.

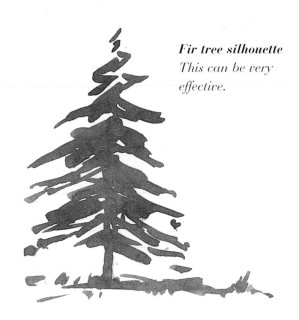

Close-up branch
Draw some close-up branches with your 2B pencil. Then add colour.

Distant autumn trees
A very simple suggestion of distant trees. Paint using your small brush with one wash.

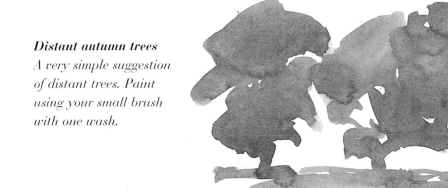

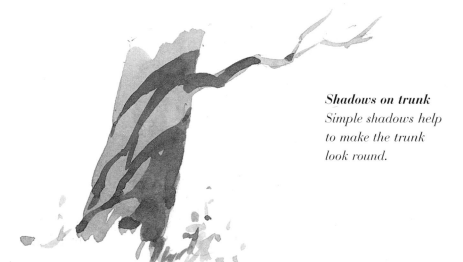

Shadows on trunk
Simple shadows help to make the trunk look round.

EXERCISE Paint a summer tree

Don't overwork a tree in leaf. Make sure you leave sky showing through the leaves in places and show some branches, or the tree will look too solid. Until you have experience, don't paint trees too close-up; paint them in the middle distance like the one below.

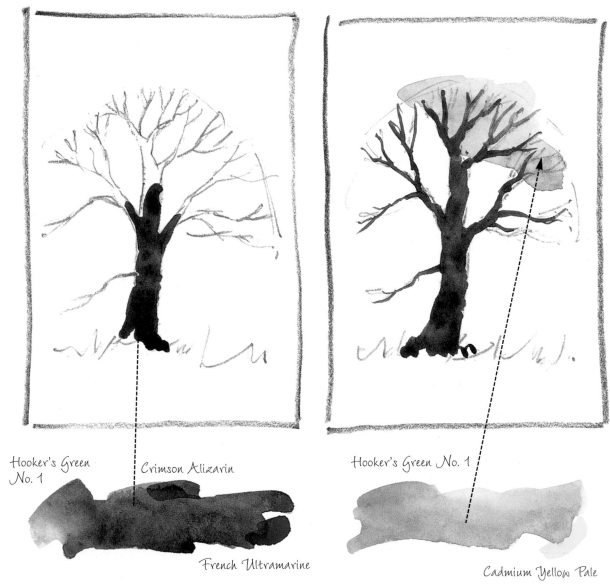

Hooker's Green No. 1 Crimson Alizarin

French Ultramarine

Hooker's Green No. 1

Cadmium Yellow Pale

1 *Draw in with your 2B pencil. Start painting the trunk working from the bottom upwards, like the winter tree (page 53).*

2 *Continue with the small branches using your rigger brush. Then start painting a wash of green from the top.*

The palette

Hooker's Green No. 1

Crimson Alizarin

French Ultramarine

Cadmium Yellow Pale

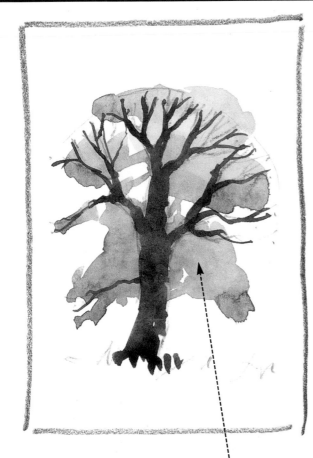

Crimson Alizarin

Hooker's Green No. 1

Hooker's Green No. 1

Crimson Alizarin

Cadmium Yellow Pale

3 Continue with the green wash using free brush strokes. Let the brush strokes dictate the shapes.

4 Using the same brush stroke, paint in the darker foliage. Go over the trunk, then paint the ground. The fence posts suggest scale.

DISTANCE AND FOREGROUND

When painting distant objects, one very important rule of thumb is that cold or cool colours – blues – recede into the distance, and warm colours – reds – advance. This means that colours you use for distant objects are in the blue cool range and colours for the foreground are in the red warm range. Another important rule is that objects in the foreground are more detailed than those in the distance.

Distant village

This picture contains many optical illusions to show distance. The clouds get smaller to the horizon. The distant trees and buildings are cool blue/grey, and the warmer colours are in the foreground. The road leads you into the distance, the distant buildings are pale and not painted in any detail, and the telegraph poles get smaller as they get further away.

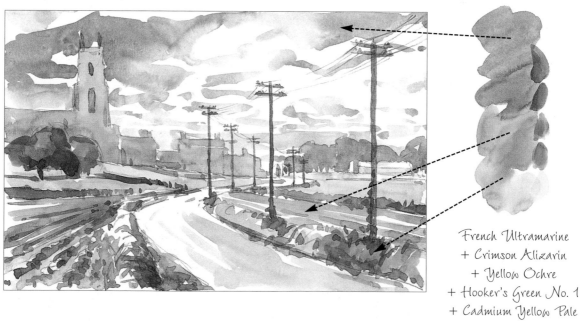

French Ultramarine
+ Crimson Alizarin
+ Yellow Ochre
+ Hooker's Green No. 1
+ Cadmium Yellow Pale

The most important thing to remember is that although I could see the village in reasonable detail, I had to simplify it to keep it in the distance. Notice there is no detail, except for the church windows. The silhouette shape of the buildings is important.

Distant hills

This is a very good simplified example to show how cool colours recede. It includes another optical illusion; colours get paler as they recede into the distance. You can often see this very clearly in hilly countryside. Note the warm colour used for the foreground field.

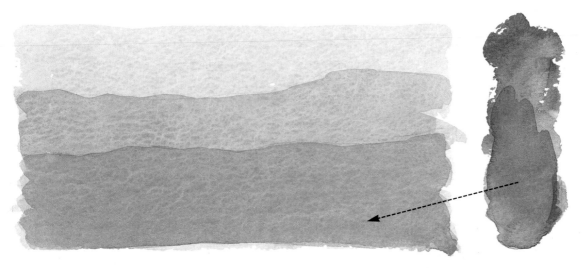

French Ultramarine
+ Crimson Alizarin
+ Yellow Ochre

1 *Paint a pale blue wash down to the field. When dry, paint over it with a darker wash. Finally, when this is dry, paint a third even darker wash over the last.*

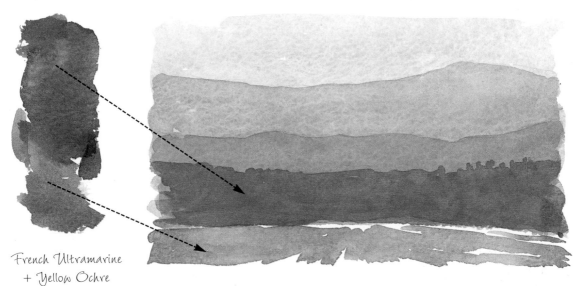

French Ultramarine
+ Yellow Ochre
+ Crimson Alizarin

2 *Paint in the last dark hill. Let the brush bounce around at the top to represent simple silhouettes of trees. Finally, paint the warm foreground field.*

Foreground path with fence

One of the biggest problems that beginners have with the foreground is that they try to include too much detail. Keep the foreground simple. Look how simple mine is in the exercises on these pages, and on page 58.

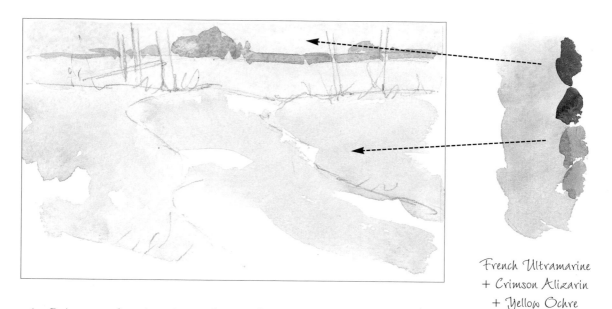

French Ultramarine
+ Crimson Alizarin
+ Yellow Ochre
+ Hooker's Green No. 1

1 *Paint a wash, using plenty of water, from top to bottom, changing the colour as you go. When dry, paint in the distant trees.*

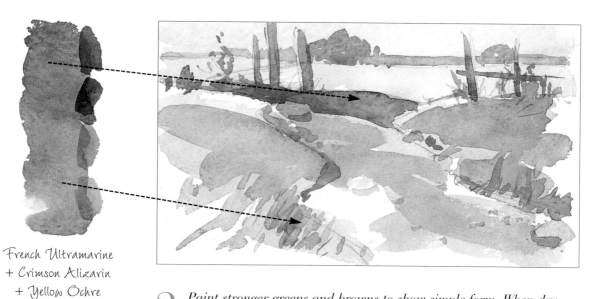

French Ultramarine
+ Crimson Alizarin
+ Yellow Ochre
+ Hooker's Green No. 1

2 *Paint stronger greens and browns to show simple form. When dry, paint in the fence and shadows.*

Foreground snow

Watercolour is a great medium for painting snow. Let the white paper be your lightest snow areas and add washes to show form and shape. Keep the snow simple.

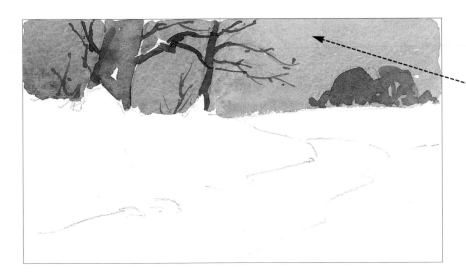

French Ultramarine
+ Crimson Alizarin
+ Yellow Ochre
+ Hooker's Green No. 1

1 *Paint in the sky leaving the big tree trunk as white paper. When dry, paint in the trees. Leave an area of unpainted paper at the bottom of the trunks to represent snow.*

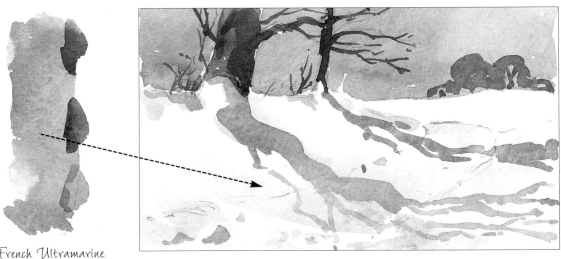

French Ultramarine
+ Crimson Alizarin
+ Yellow Ochre

2 *With free, simple brush strokes, paint washes to show the contours of the snow. When dry, paint in the tree shadows. Remember to keep it simple.*

DEMONSTRATION LANDSCAPE

👀 *AT A GLANCE...*

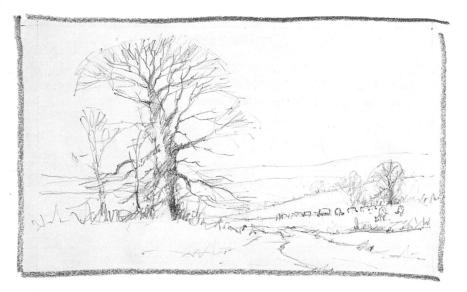

1 *Draw this landscape on cartridge paper with your 2B pencil. Shade in the shadow areas on the trees. This shading and pencil work will help to make the painting look more 'alive' and complicated when you paint it. I work a lot like this when I am painting outdoors.*

2 *Using your big brush, paint a wash for the sky, changing the colours as you get nearer the horizon. Leave some 'flecks' of white paper showing to represent distant clouds. Paint the sky over the distant hills. Use French Ultramarine, Crimson Alizarin and Yellow Ochre.*

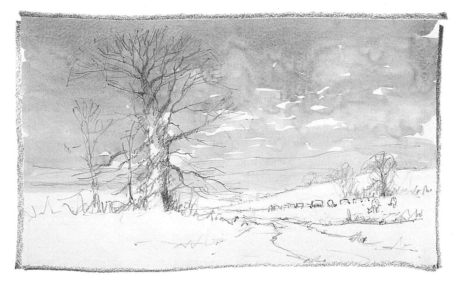

The palette

French Ultramarine

Crimson Alizarin

Cadmium Yellow Pale

Yellow Ochre

Hooker's Green No. 1

3 *Using your big brush, paint the distant hills in two washes, as you did on page 59. Don't paint over the tree trunk. Now paint the distant fields, working down to the foreground field. Leave the cows unpainted. Note how freely this was painted.*

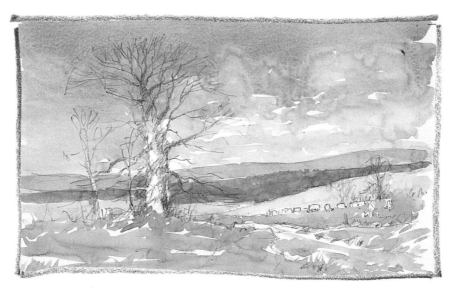

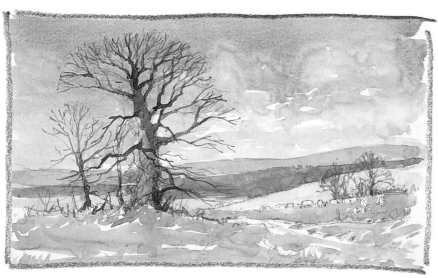

4 *Now paint in the main trees. Use your small brush for the main trunk and large branches and your rigger brush for the small branches and small trees. Notice how I have painted the left hand side of the main tree trunk paler to show the sunlight on it.*

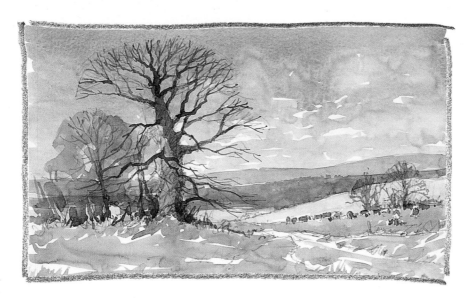

5 Now with a wash of Cadmium Yellow Pale, Crimson Alizarin and French Ultramarine, paint the autumn colour on the left-hand trees. Let the colours mix on the paper (wet-on-wet, page 14). Notice how the cool colours (hills) recede and the warm colours (trees and foreground) come forward.

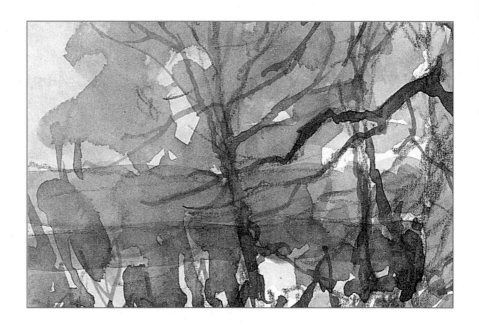

Detail: *Paint the autumn colours in one wash over all the branches. Look how I have left areas of background (sky and hills) to show through. Don't try to copy mine, it's impossible – let this happen accidentally as you paint.*

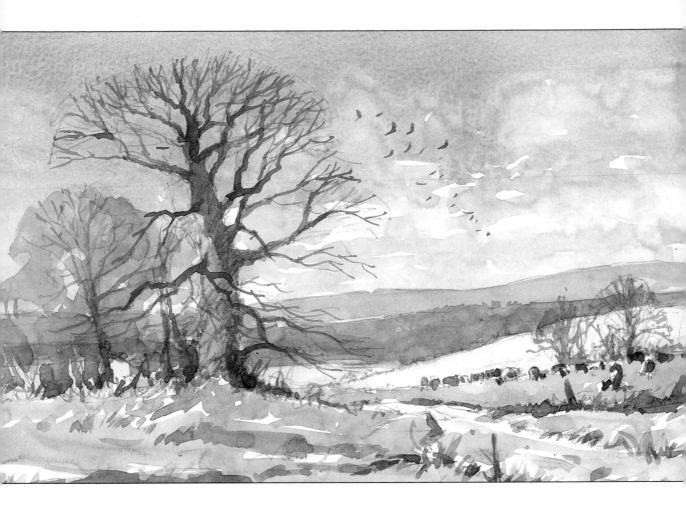

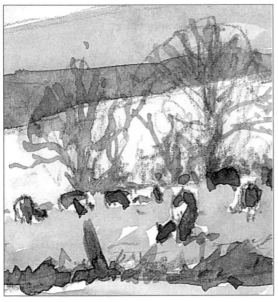

6 *Finished picture: cartridge paper, 19 x 30 cm (7½ x 12 in). Suggest a simple foreground with shadows. Paint the cows darker and add the birds. This painting looks complicated, but remember that it is built up using simple techniques. It is only when everything is put together that it looks complete and complicated.*

Detail: *Notice how freely the cows and trees have been painted. Look how the distant hills recede.*

ANIMALS AND BIRDS

If you enjoy painting landscapes, then you will need to practise painting the landscape's animals and birds. Some need more drawing than others. If you find that these are too difficult to begin with, don't put them in your picture until you feel more confident. The secret of painting animals is to practise painting them from life or from photographs until you are familiar with them.

Cows

Cows are perhaps the most common animals seen in the countryside. If you put any animal into a landscape painting, but especially cows, it gives the picture atmosphere and life.

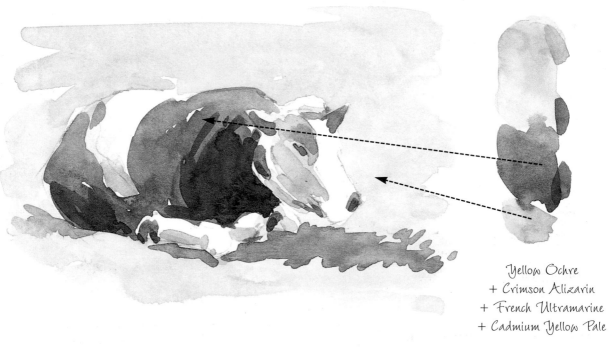

Yellow Ochre
+ Crimson Alizarin
+ French Ultramarine
+ Cadmium Yellow Pale

The drawing was important, but notice how I made the black areas on top 'light' and painted darker 'black' areas to show form, to make the cow look solid (page 22). I left the whitest whites as paper. Notice how the shadow helps the cow to 'sit' on the ground.

Sheep

Sheep are perhaps the easiest animals to paint within a landscape. In the distance they can be suggested by just leaving small shapes of unpainted paper. Even when they are closer the drawing is easy and they are simple to paint.

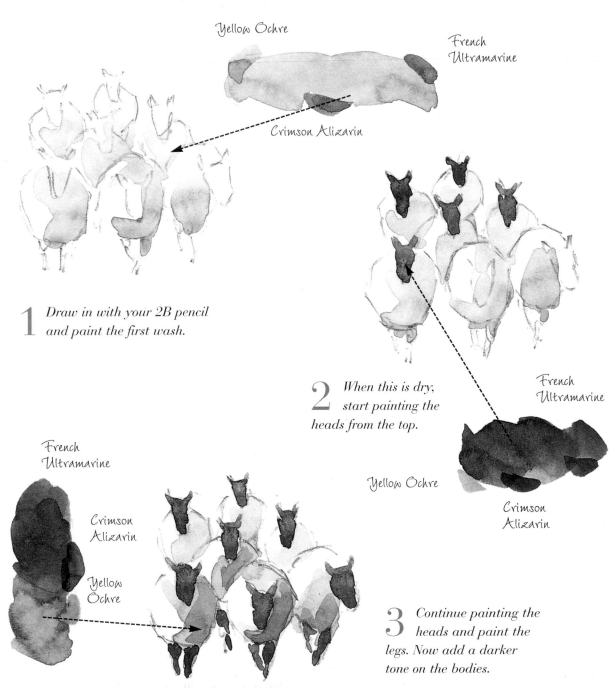

Yellow Ochre

French Ultramarine

Crimson Alizarin

1 *Draw in with your 2B pencil and paint the first wash.*

French Ultramarine

2 *When this is dry, start painting the heads from the top.*

Yellow Ochre

Crimson Alizarin

French Ultramarine

Crimson Alizarin

Yellow Ochre

3 *Continue painting the heads and paint the legs. Now add a darker tone on the bodies.*

Sheepdog

Sheepdogs are usually seen around farms and are typical farm working dogs. A sheepdog has a unique visual character with its large, shaggy white tail and chest.

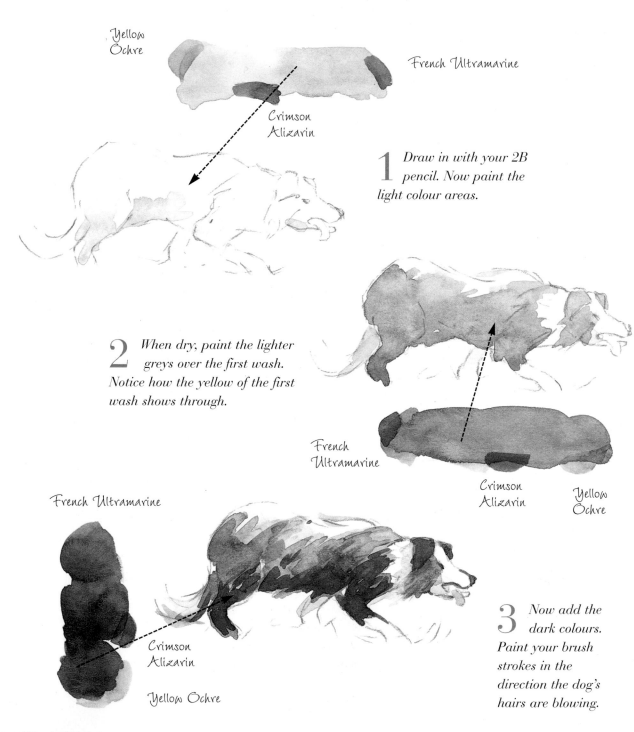

Yellow Ochre

French Ultramarine

Crimson Alizarin

1 *Draw in with your 2B pencil. Now paint the light colour areas.*

2 *When dry, paint the lighter greys over the first wash. Notice how the yellow of the first wash shows through.*

French Ultramarine

Crimson Alizarin

Yellow Ochre

French Ultramarine

Crimson Alizarin

Yellow Ochre

3 *Now add the dark colours. Paint your brush strokes in the direction the dog's hairs are blowing.*

Farm horse

The horse with its harness is far more complicated than the sheep or dog, but it is worth practising as it adds a certain nostalgia to a landscape painting. Practise from life or photographs but first copy this one – it's a challenge!

1 *Draw the horse carefully with your 2B pencil. Then paint the first wash.*

Yellow Ochre

Crimson Alizarin

French Ultramarine

2 *Paint the brass on the harness and the shadows on the horse's hooves.*

Yellow Ochre

Crimson Alizarin

French Ultramarine

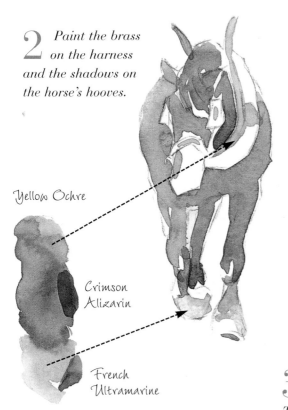

Yellow Ochre

Crimson Alizarin

French Ultramarine

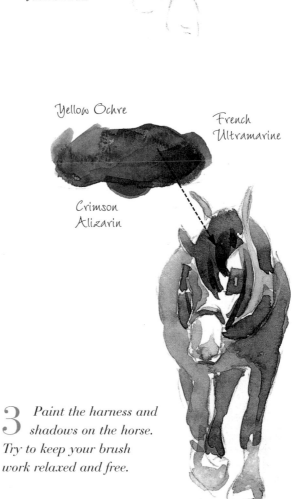

3 *Paint the harness and shadows on the horse. Try to keep your brush work relaxed and free.*

Duck

Where you have water in your landscape, a duck is always useful for adding life to the scene. I find they have more character out of water than swimming on it. In fact they can make quite a fun element in a painting.

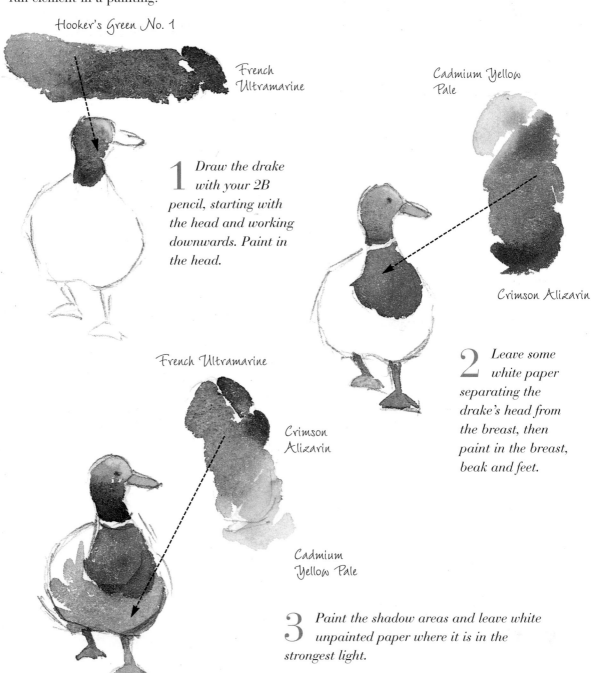

Hooker's Green No. 1

French Ultramarine

Cadmium Yellow Pale

Crimson Alizarin

1 *Draw the drake with your 2B pencil, starting with the head and working downwards. Paint in the head.*

French Ultramarine

Crimson Alizarin

Cadmium Yellow Pale

2 *Leave some white paper separating the drake's head from the breast, then paint in the breast, beak and feet.*

3 *Paint the shadow areas and leave white unpainted paper where it is in the strongest light.*

Sketching birds

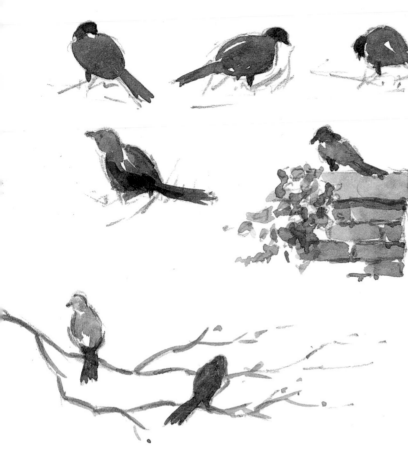

Birds standing
*At this size don't put
in any detail. The
silhouette shape is
enough.*

Birds in flight
*Just two brush
strokes, one for each
wing, is sufficient. But use
single and receding smaller
strokes for the birds in the distance.*

Birds on branches
Again, the silhouette shape is enough.

Pheasants
*The long tail and bright colours
make these birds very enjoyable
to paint.*

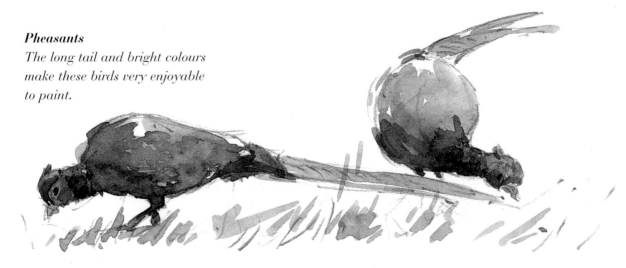

EXERCISE Paint animals

If you look at each individual cow, this painting is not as daunting as it looks. Paint each cow individually and the background and foreground will hold the painting together. Notice how the foreground is painted very simply (page 60).

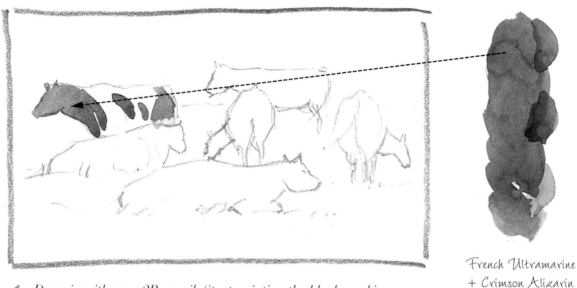

French Ultramarine
+ Crimson Alizarin
+ Yellow Ochre

1 *Draw in with your 2B pencil. Start painting the black markings on the top of the top left-hand cow.*

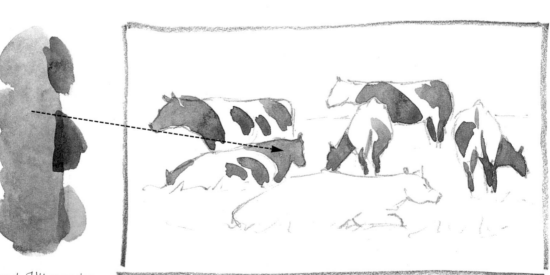

French Ultramarine
+ Crimson Alizarin
+ Yellow Ochre

2 *Continue painting the black markings. Make sure you curve them round the cow's body, or your cows will look flat!*

The palette

French Ultramarine

Crimson Alizarin

Yellow Ochre

Hooker's Green No. 1

Cadmium Yellow Pale

Cadmium Yellow Pale
+ Hooker's Green No. 1
+ French Ultramarine
Yellow Ochre
+ Crimson Alizarin

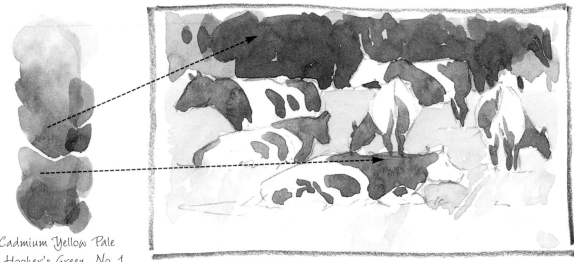

3 *Paint the brown and white cow. Note how I put this 'warm-coloured' cow in the foreground (page 58). Paint in the grass and background.*

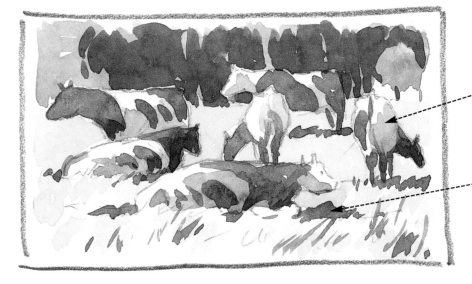

French Ultramarine
+ Crimson Alizarin
+ Yellow Ochre

4 *Paint darker shadows on the cows and grass. Notice that I have left the eye in the brown cow in pencil, because it looks OK. Keep it simple!*

You can paint 73

PEOPLE

Painting people, or life painting, as it is known, is very exciting and complex. Here I want to show you how you can simplify people so that you can put them in your paintings. This is not a lesson in figure drawing, it is a lesson in simplification.

Animation

If possible you want to animate your people. One simple way of doing this is with the head. On the right are five bald heads. Below them I have added hair using just one brush stroke. Now they are looking in a definite direction.

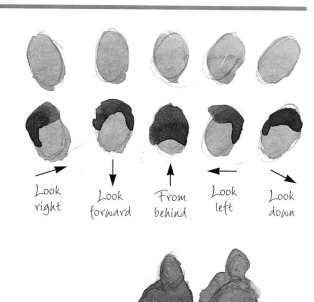

Look right Look forward From behind Look left Look down

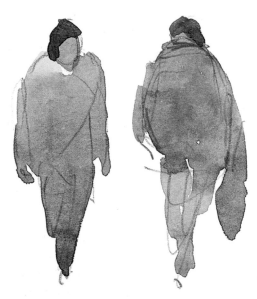

The two people above are looking at each other as they pass. I did this by tilting their heads and adding the hair with a single brush stroke. The body was started at the top and worked down in one movement, adding a change of colour as I went (wet-on-wet, page 14).

These silhouette figures were painted from the head downwards in one movement, letting them merge together where they touched. Don't put feet on them.

Mother and child

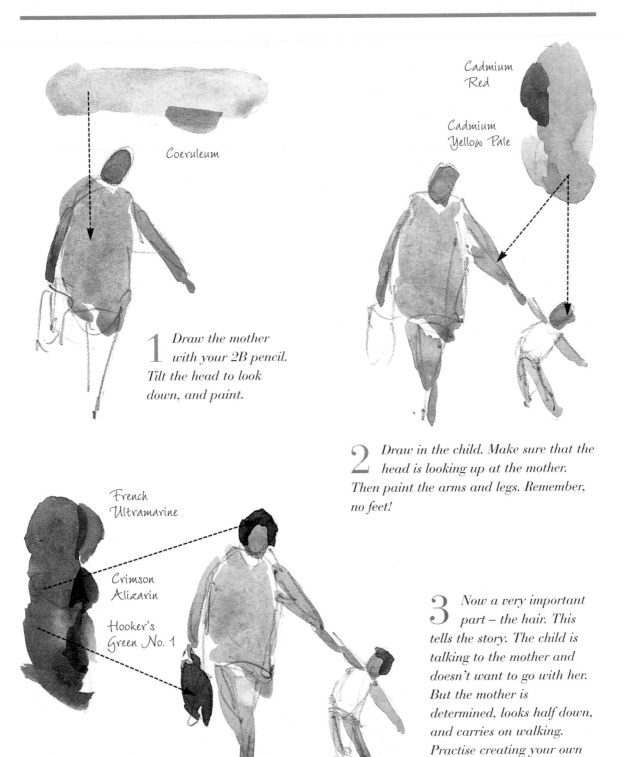

Coeruleum

1 *Draw the mother with your 2B pencil. Tilt the head to look down, and paint.*

Cadmium Red

Cadmium Yellow Pale

2 *Draw in the child. Make sure that the head is looking up at the mother. Then paint the arms and legs. Remember, no feet!*

French Ultramarine

Crimson Alizarin

Hooker's Green No. 1

3 *Now a very important part – the hair. This tells the story. The child is talking to the mother and doesn't want to go with her. But the mother is determined, looks half down, and carries on walking. Practise creating your own situations.*

EXERCISE Paint people

A group of people can give life and interest to a painting. But keep them simple. Don't put in detail or they will jump out of the picture. Don't forget to animate their heads.

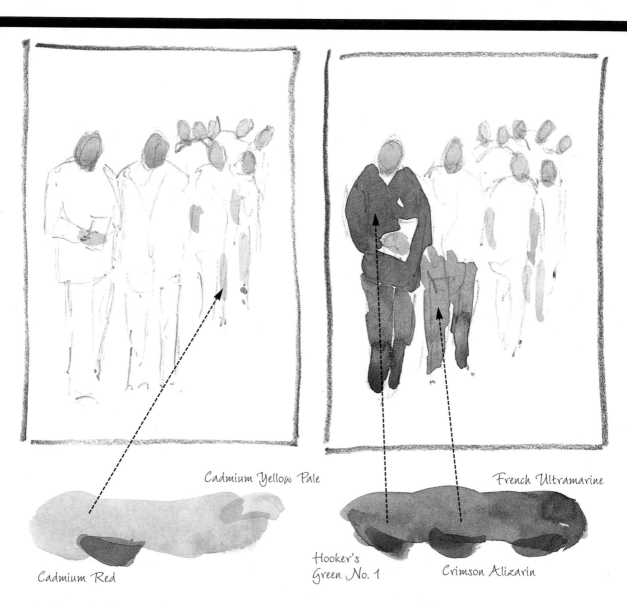

Cadmium Yellow Pale

Cadmium Red

French Ultramarine

Hooker's Green No. 1

Crimson Alizarin

1 *Draw the figures using a 2B pencil, but don't draw any detail. Paint in their heads, arms and legs.*

2 *Now paint in the two foreground figures. Notice how the green jacket has run into the blue trousers. This helps to keep them free.*

The palette

Cadmium Red

Cadmium
Yellow Pale

Hooker's
Green No. 1

Crimson
Alizarin

French
Ultramarine

Yellow Ochre

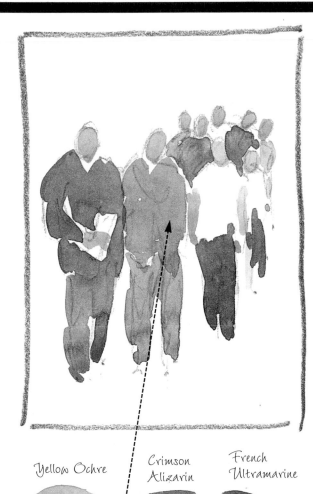

Yellow Ochre Crimson
Alizarin French
Ultramarine

3 *Continue painting in the figures. Notice
how the white areas of unpainted paper
work well for two of the figures.*

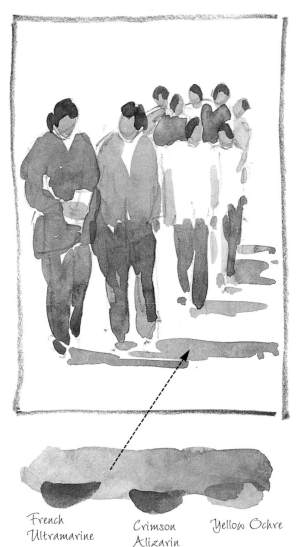

French
Ultramarine Crimson
Alizarin Yellow Ochre

4 *Now paint the hair and see how the
people come alive. Paint in the shadows
on the ground to stop them floating.*

SIMPLE BUILDINGS

A building without its details is just like the box you practised painting earlier, on page 22. Naturally this is over-simplifying things. But remember, if you can look at an object or scene and simplify it in your mind's eye for painting before you start, you are well on the way to becoming a good artist.

Simplify

If you stood in the high street and were asked to paint it, it would naturally be too complicated for you. Before you can paint buildings, you must learn to simplify. Here are two very different but simple ways to make a start.

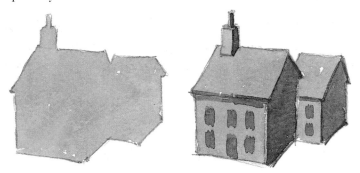

The house was a flat shape before the shadow was added. Remember, light against dark gives shape and form (page 22).

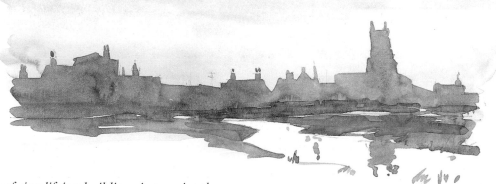

A way of simplifying buildings is to paint them in silhouette against a bright sky or sunset. It is only the outline form you need to concentrate on. I drew these then painted the sky down

and into the foreground. When dry I painted the buildings wet-on-wet, changing the colours very subtly as I worked (page 14).

Simple village

These village houses are all based on the box (page 22) and the yellow house opposite. It is light against dark that shows the form. I keep repeating this but it is most important. Look at the church tower in stage 1. It looks completely flat. Put a shadow on, stage 2, and it becomes solid.

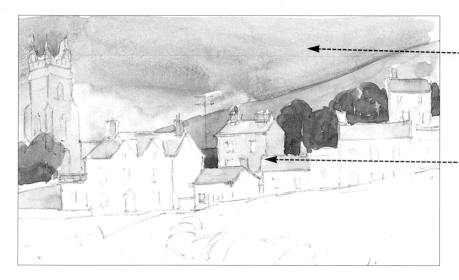

French Ultramarine
+ Crimson Alizarin
+ Yellow Ochre

1 *Draw in with your 2B pencil. Paint in the colours on this first stage. Note that the painting looks flat, but look how the yellow house stands out – light against the dark background.*

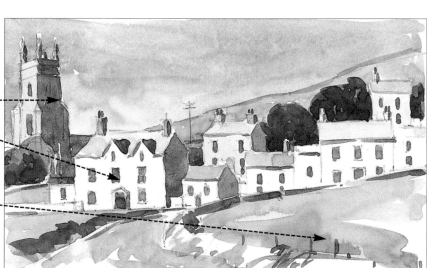

French Ultramarine
+ Crimson Alizarin
+ Yellow Ochre
+ Hooker's Green No. 1
+ Cadmium Yellow Pale

2 *The sun is on the left, therefore the shadows are on the right. Paint them in and with the same colour paint the windows. Notice they are just square blobs of paint – no detail. Now paint the simple foreground.*

Paint buildings

I have chosen this scene, made up from a real place with my own additions, to show how light against dark shows form and shape. Remember that to get crisp edges you must apply paint on to dry paint; if it is wet your colours will merge and you will lose the shapes of the buildings.

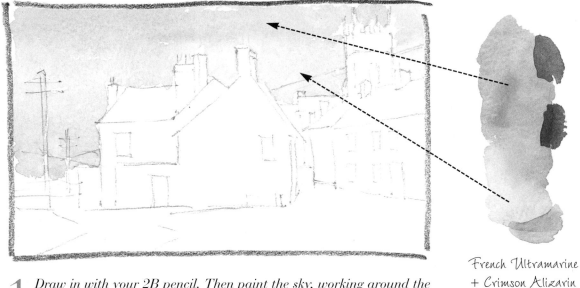

*French Ultramarine
+ Crimson Alizarin
+ Yellow Ochre*

1 *Draw in with your 2B pencil. Then paint the sky, working around the buildings. Use a graded colour wash (page 13).*

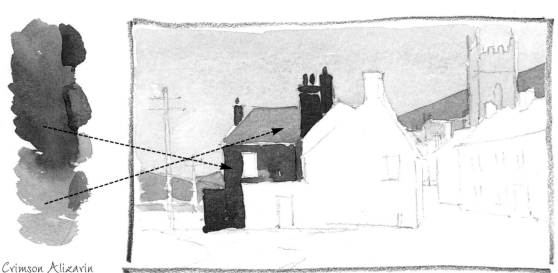

*Crimson Alizarin
+ French Ultramarine
+ Yellow Ochre
+ Cadmium Red*

2 *Paint the background hills, the church tower and dark house. It is important to get the silhouette shapes of the church and house correct.*

The palette

French Ultramarine

Crimson Alizarin

Yellow Ochre

Cadmium Red

French Ultramarine
+ Crimson Alizarin
+ Yellow Ochre

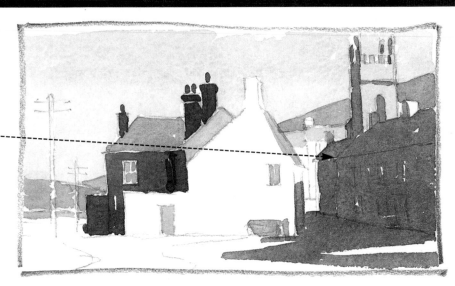

3 *With a shadow colour wash (page 22), paint down the church tower and the row of houses, on the road and up one side of the white house. Paint the windows and door.*

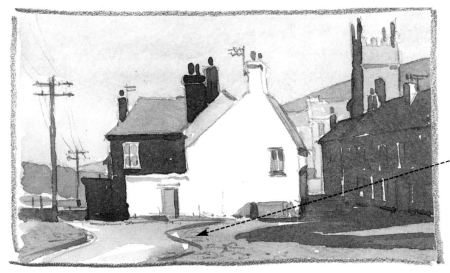

Yellow Ochre
+ Crimson Alizarin

4 *Paint the foreground with a warm wash and go over the shadow. Finally add a few dark accents where you feel they are needed.*

WATER

When water is painted well, it always looks good in a painting. The biggest trap that beginners fall into is to overwork water, making it look too complicated and unrealistic, and getting it less 'watery' with each brush stroke. The secret with water is to keep it simple, do not overwork it.

Reflections

Look how simple this water is. The water is unpainted paper. It is just the reflection that makes it appear to be water. It is important to put reflections into your water where possible.

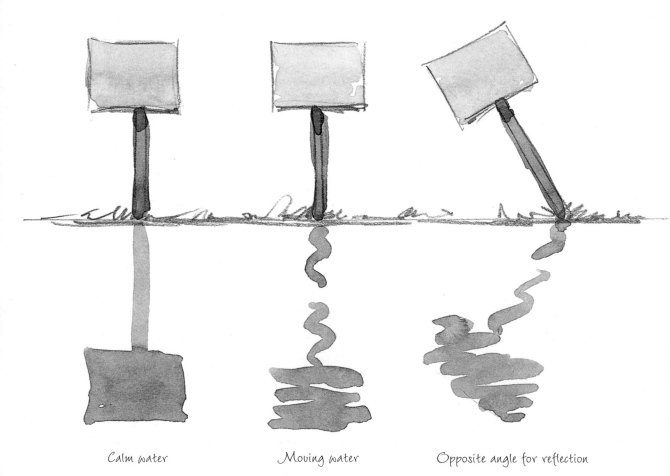

Calm water Moving water Opposite angle for reflection

Still water

If the water is without movement, the images are reflected mirror-like. But don't get too fussy about an exact image; it is a painting you are doing, not a photographic copy.

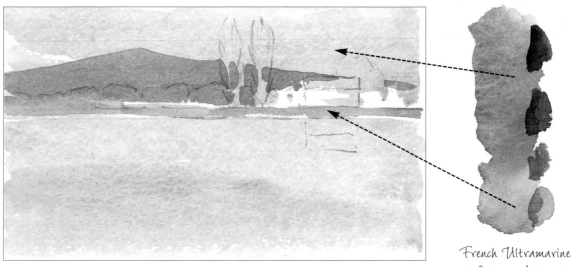

1 *Paint the sky down to the horizon, leave white paper for the flat land area and continue with the water. When dry paint the hill and flat land.*

French Ultramarine
+ Crimson Alizarin
+ Hooker's Green No. 1
+ Yellow Ochre

Hooker's Green No. 1
+ Yellow Ochre
+ Crimson Alizarin
+ French Ultramarine

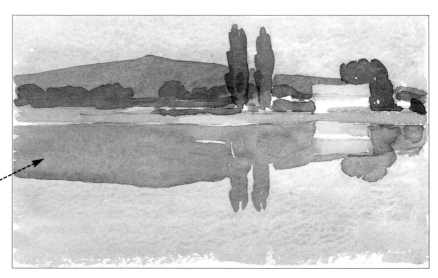

2 *Finish the land and then paint in the reflections with one wash, starting with green and changing to grey. Remember, keep it simple, don't be tempted to keep working at it.*

Moving water

Moving water like a river, or water with movement on it created by the wind or boat traffic, is easy to do in watercolour and looks very effective.

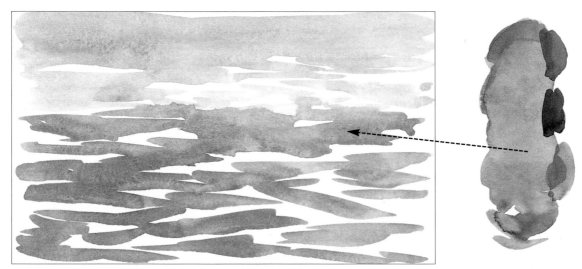

1 *Using broken horizontal brush strokes, start at the top and work down. Leave areas of white paper for reflected light on the water.*

French Ultramarine
+ Crimson Alizarin
+ Yellow Ochre

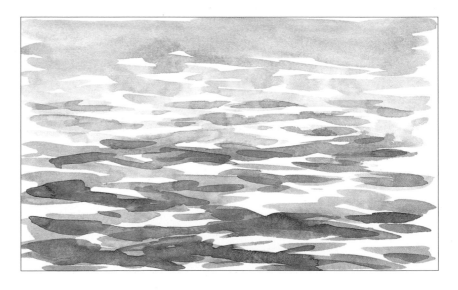

French Ultramarine
+ Crimson Alizarin
+ Yellow Ochre

2 *When the first stage is dry, paint over the top with darker colour, still using broken horizontal brush strokes.*

Estuary water

There are no reflections from the land in this water. This often happens when the water is a long way off. But if you look again, you can see reflections in the water from the sky. It is this that helps the estuary look like water. Remember, the sky is always reflected in water.

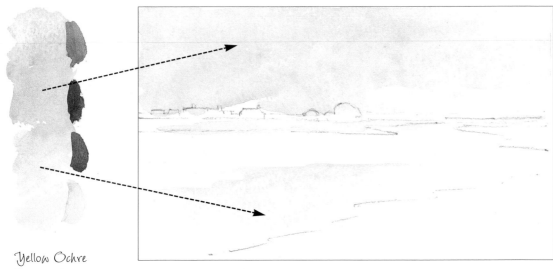

Yellow Ochre
+ Crimson Alizarin
+ French Ultramarine
+ Cadmium Yellow Pale

1 *Paint in the sky and water with the same colours. Leave some white unpainted paper in the distant water. Paint in the land.*

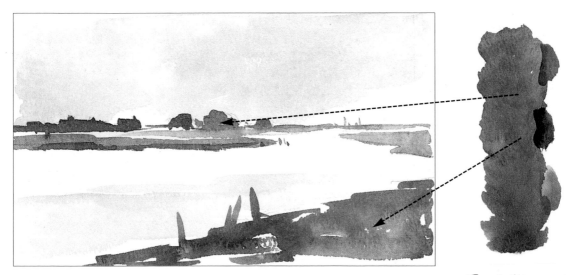

2 *Paint in the landscape. The time is evening and so it is in silhouette. Another reason the estuary appears to be water is that the land is dark against the very light water.*

French Ultramarine
+ Crimson Alizarin
+ Yellow Ochre

Boats

When you paint water you will at some time have to paint boats. You need to be reasonably good at drawing to tackle some boats, but there are ways of simplifying them. One way is to paint them in silhouette (see opposite). This takes away the need to include difficult detail.

1 *This boat has one wash painted over it. This is the same as the box on page 22.*

2 *Add the shadow with one wash and the boat becomes a solid 3D object and not a flat shape.*

1 *This small cruiser requires more drawing, but the shapes are simple – observe them carefully. Then paint the first wash. The two men give scale to the boat.*

2 *Paint the dark shadows and finally the reflection. It now looks as if it is in water.*

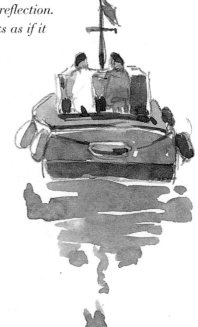

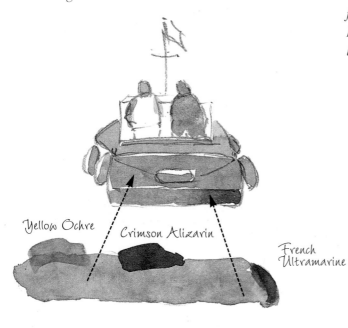

Yellow Ochre

Crimson Alizarin

French Ultramarine

Sketching boats

Take your sketchbook out and enjoy a day sketching boats. Don't draw or paint any in the foreground. Draw them from a distance and you will lose a lot of the complicated detail. Detail will come automatically the more you practise.

Distant yacht
The white sail is the most important part of this sketch, because it is a recognisable image.

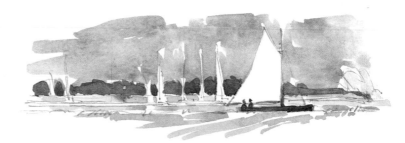

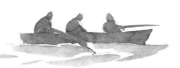

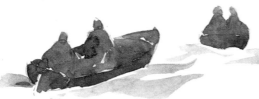

Silhouettes
Silhouettes are not an easy way to avoid learning to draw! But they are easier for a beginner to paint. Remember, a silhouette can be dark against light, or light against dark.

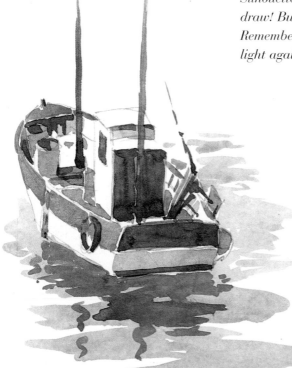

Fishing boat
This is the most adventurous sketch. You need to have drawing skills for this. But look how simple the painting is, using light against dark to show form. And the reflection is painted very simply.

Paint a boat

If you look at stage 4, this fishing boat looks complicated to paint. However, if you follow the stages carefully and you have been practising, you won't have any problems. But first you must draw it carefully. Remember, the more you practise the better you will get.

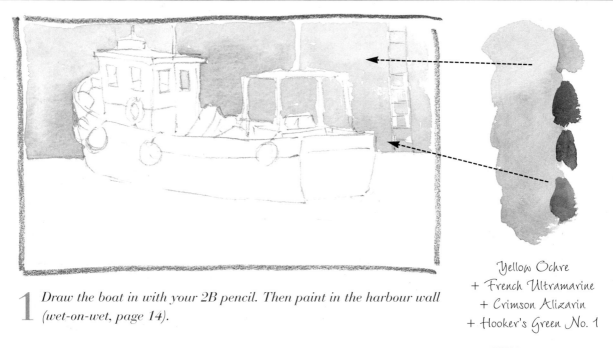

Yellow Ochre
+ French Ultramarine
+ Crimson Alizarin
+ Hooker's Green No. 1

1 *Draw the boat in with your 2B pencil. Then paint in the harbour wall (wet-on-wet, page 14).*

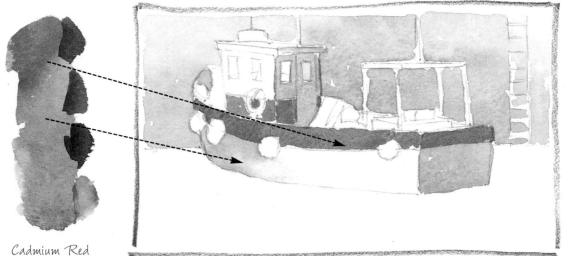

Cadmium Red
+ French Ultramarine
+ Crimson Alizarin
+ Yellow Ochre

2 *When this is dry, paint the red colour on the boat. When dry, paint the shadow areas, going over the red on the shadow sides.*

The palette

Yellow Ochre

French
Ultramarine

Crimson Alizarin

Hooker's
Green No. 1

Cadmium Red

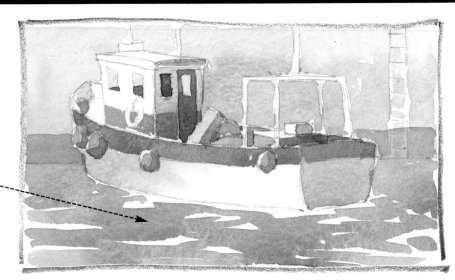

Hooker's Green No. 1
+ French Ultramarine
+ Yellow Ochre

3 *Add more work to the boat and then paint in the water as you did for the exercise on page 84.*

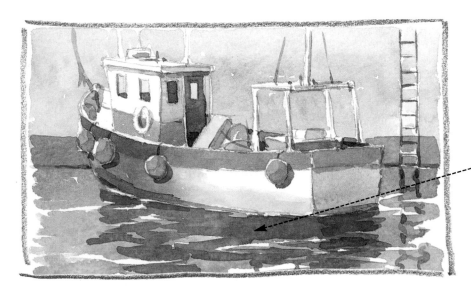

4 *Add some more darks and shadows to the boat. Paint in the ladder. Finally, paint in the reflections.*

Hooker's Green No. 1
+ French Ultramarine
+ Crimson Alizarin

You can paint 89

Pebble beach

The coast is full of subjects for watercolour. Because you can see the horizon you get vast, uninterrupted skies to paint. But the obvious subjects are the beach and sea. Below is just one way of painting a pebble beach.

Crimson Alizarin
+ Yellow Ochre
+ French Ultramarine

1 *Paint a wash, followed by another one with stronger colours. Then, with a tissue, lift out paint to represent pebbles (page 17).*

Crimson Alizarin
+ Yellow Ochre
+ French Ultramarine
+ Pencil

2 *With stronger colour and shadow colour, suggest the pebbles. Finish by drawing some pebble shapes with your 2B pencil over the dry paint.*

Waves

Waves are always moving and are therefore difficult to paint. It is helpful to sit and watch the patterns that they make until you become familiar with the shapes. You could also use photographs as a guide.

French Ultramarine
+ Crimson Alizarin
+ Hooker's Green No. 1
+ Yellow Ochre

1 *With a wet-on-wet wash (page 14), paint in the water, leaving white paper for the light coloured foam.*

2 *Using darker colours, paint under the breaking waves, and the beach. Now with a wet brush, lift out areas to represent fine spray (page 17). Then add some dark brush strokes to represent thrown pebbles.*

French Ultramarine
+ Crimson Alizarin
+ Hooker's Green No. 1
+ Yellow Ochre

Sketching the coastline

Don't forget your sketchbook! There's always time and subjects to practise on, especially at the coast. Remember, sketches are a means of gathering information, but more importantly for a beginner, they are a way to enjoy practising. It isn't the end result that matters, it's the fact that you have observed and drawn, gathering experience.

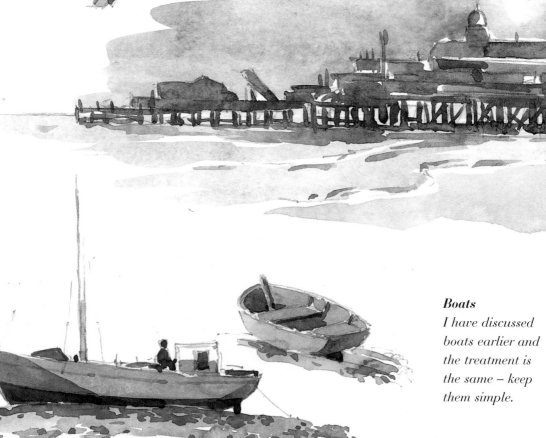

Deckchair
These are almost as difficult to sketch as to put up! This is a very well-known seaside image.

Pier
This is in silhouette, but you don't see detail if it is in the middle distance. Notice how simple the sea is.

Boats
I have discussed boats earlier and the treatment is the same – keep them simple.

Cliffs

Another traditional coastline view. Cliffs are simple to sketch, but very dramatic. Note how the people give scale.

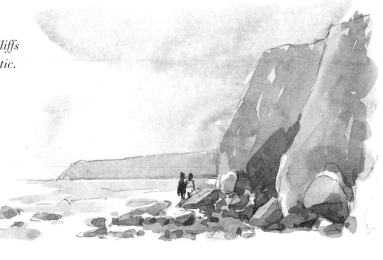

Crab

This is easy to draw but more difficult to paint. The shell and claws were done wet-on-wet (page 14). When dry, another wash was applied to give crispness to the shell.

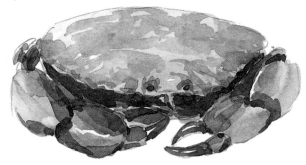

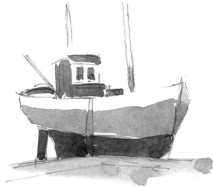

The red boat

This is painted very simply using just two washes.

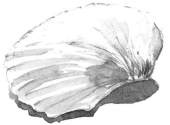

Shell

You can find these almost anywhere, and you can paint them on the beach or at home.

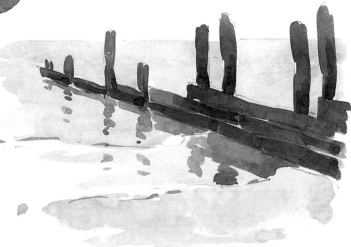

Windbreaks

This simple sketch works because the subject is uncomplicated and it is painted dark (posts) against light (sea). Remember, silhouette shapes are very effective in watercolour.

 AT A GLANCE...

 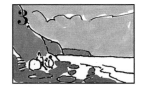 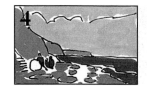

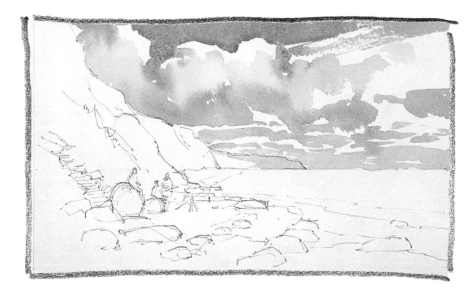

1 Draw in with
your 2B pencil.
With your big brush
paint in the sky; do
the blue sky first.
Then paint the clouds,
letting the colour
merge with the blue
sky in places. Leave
some untouched edges
to form crisp white
clouds. Paint the
distant clouds thinner.

2 Paint in the
cliffs. Start with
the distant ones in
cool colours and
work towards the
nearest cliff making
the colours warmer.
Leave some 'white'
sunlit areas on the
distant cliffs at the
bottom, and on the
foreground cliff.

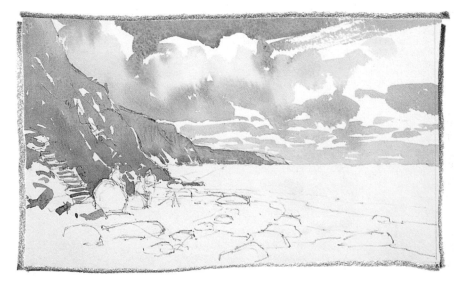

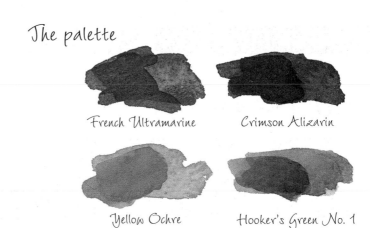

French Ultramarine

Crimson Alizarin

Yellow Ochre

Hooker's Green No. 1

3 Continue the cliff painting into the beach. Use the same colours, but more Yellow Ochre for sand and pebbles. Paint the rocks freely, leaving small areas of white paper to represent water and sunlight on rocks.

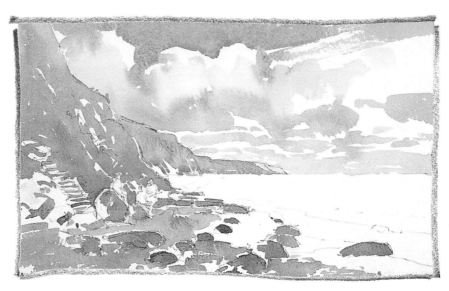

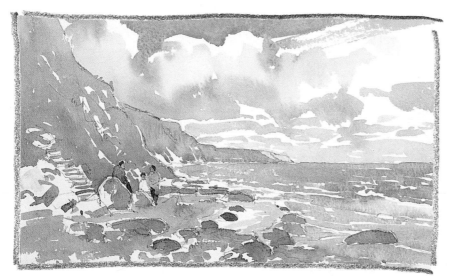

4 Using your small brush, paint the sea. Add Hooker's Green No.1 to French Ultramarine at the horizon, and then continue with the blue only. Paint in horizontal brush strokes and leave white areas to represent waves. Paint in the fishermen.

You can paint 95

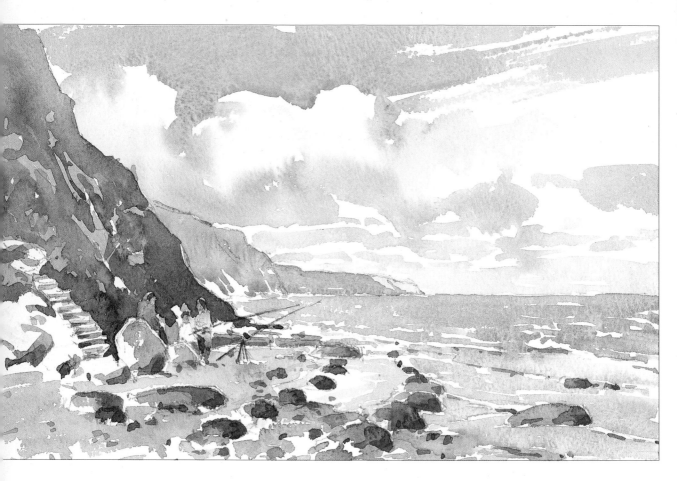

5 **Finished picture:** *Bockingford water-colour paper, 19 x 30cm (7½ x 12 in).
This is the part that brings the foreground towards you, and moves the distant cliffs away from you. Paint a dark wash on the foreground cliff, changing the colours as you work (wet-on-wet, page 14). Put dark shadows on the rocks and finally paint in the fishing rods.*

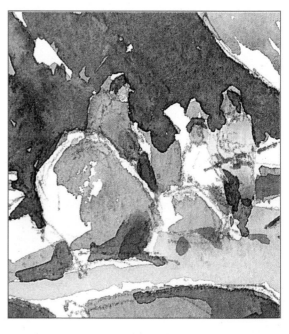

Detail: *This is the most important part of the painting. The dark cliff against the distant light cliffs creates distance, and the fishermen give life and mystery – what are they talking about?*